# CADBURY & FRY

## THROUGH TIME

Paul Chrystal

AMBERLEY

# About the Author

Paul Chrystal is author of the following titles in the Amberley Publishing *Through Time* series published in 2010: *Knaresborough; North York Moors; Tadcaster; Villages Around York; Richmond & Swaledale; Northallerton.* He is also author of the following titles in the series, published in 2011: *Hartlepool; In & Around York; Harrogate; York Places of Learning; Redcar, Marske & Saltburn; Vale of York.* And in 2012: *York Trade & Industry; In & Around Pocklington; Barnard Castle & Teesdale; Lifeboats of the North East.* Other books by Paul Chrystal: *A Children's History of Harrogate & Knaresborough,* 2011; *A to Z of Knaresborough History Revised Edn,* 2011; *A to Z of York History,* 2012. His chocolate-related books include *Chocolate: The British Chocolate Industry,* Shire 2011; *York and Its Confectionery Industry,* Pen & Sword 2012; *Confectionery in Yorkshire – An Illustrated History,* Amberley 2012; *The Rowntree Family and York,* Amberley 2012. As well as being author and historian, Paul was a medical publisher for thirty years and, more recently, a bookseller; he lives near York.

*'Everybody wants a box of chocolates and a long stem rose.'*
Leonard Cohen

First published 2012

Amberley Publishing
The Hill, Stroud
Gloucestershire, GL5 4EP

www.amberleybooks.com

Copyright © Paul Chrystal, 2012

The right of Paul Chrystal to be identified as the Author of this work has been asserted in accordance with the Copyrights, Designs and Patents Act 1988.

ISBN 978 1 4456 0438 1

British Library Cataloguing in Publication Data. A catalogue record for this book is available from the British Library.

Typeset in 9.5pt on 12pt Celeste.
Typesetting by Amberley Publishing.
Printed in the UK.

# Introduction

The story of these two venerable British companies is quite remarkable; but it has never been told as a single history even though, after 1918, Fry and Cadbury were parts of the same organisation, albeit with separate production and branding. This book is the first to chart the history from tentative beginnings in the eighteenth and nineteenth centuries, through the dynamic years of the early twentieth, the austerity of two world wars and the post-war boom years, up until the recent takeover of Cadbury by Kraft.

Through a unique combination of a detailed and researched text complemented by around 200 images, this book shows early commercial documents, press advertisements from the dawn of British chocolate production, point of sale cards and posters, fascinating photographs of industrial processes, transportation and factory workers; packaging and branding; television advertising and programme sponsorship; and stunning marketing successes such as Cococubs. Along the way we tell the stories of such familiar brands as Fry's Chocolate Cream, Five Boys, Crunchie, Cadbury's Cocoa Essence, Dairy Milk and Milk Tray. How the companies moved away from a dependency on drinking chocolate and cocoa to eating chocolate and chocolate bars, Easter eggs and assortments is described in some detail, along with how they embraced dramatic industrial change by utilising steam power, the van Houten hydraulic press and the new railways.

The story of Fry and Cadbury would be quite incomplete without reference to the Quaker leanings of both families and the profound influence this had on their attitude to industrial relations, living and working conditions, and workers' benefits. For Fry, Quakerism was partly responsible for the move to the rural and ergonomic factory at Somerdale. For Cadbury it conveyed the same enlightened approach to employees and a similar 'factory in a garden' but augmented by a fine new garden village at Bournville, which allowed workers to live in relative comfort, hygiene and health. Sport and social activities were also paramount, as were progressive employee benefits that were years ahead of most other companies. As in any business or industry, competition was never far away and we include sporadic references to the competition from French, Swiss, Dutch, American and British chocolate companies throughout the text.

Paul Chrystal, York

# Acknowledgements

Thanks go to the following for their help and support in the research for this book and in the provision of images; without them the book would be much diminished: Sarah Foden, Cadbury Archive, Kraft Foods for many of the Fry and Cadbury images; Jennifer Carnell at Sensation Press for the pictures on pages 8 (lower) and 49 (lower) www.sensationpress.com; Hayley Coggins, Elizabeth Shaw Limited. Special thanks also to Alan Freke, Frenchay Village Museum,

www.frenchaymuseum.com for allowing me to use the images on pages 6–9, 22 (top) and 29 taken from *J.S. Fry & Sons: A Rough Guide to the Family & the Firm*. And also to Dudley Chignall for allowing me to use the images on pages 90–93 originally published in his *The Cadbury Cococubs – Celebrating 75 Years* and in *Ernest Aris – The Man Who Drew for Beatrix Potter* for which see www.cococubs.com.

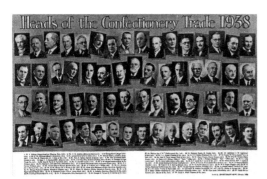

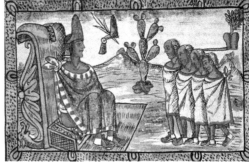

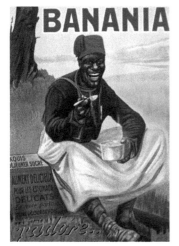

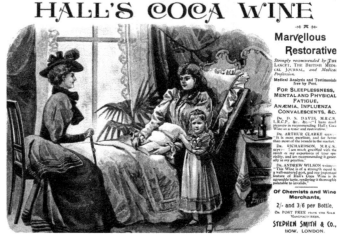

*Clockwise from top left*: (i) *La crème de la crème* of the European confectionery industry in 1938. Edward Cadbury is sixth from the left, top row; Cecil R. Fry is fourth from the right, top row. (ii) The dawn of the chocolate age: the Aztec Montezuma II briefing his envoys on a meeting with the conquistadores. Cortes had come looking for El Dorado but returned home around 1520 with cocoa, thus introducing cocoa, and ultimately chocolate, to Europe. (iii) Competition from other beverages – alcoholic, non-alcoholic and the medically endorsed chemical, as here with coca wine and from (iv) the French and Anglo-Dutch with the often controversial advertisements for their chocolate-banana drink in 1915, originally manufactured by Unilever.

# J. S. FRY & SONS

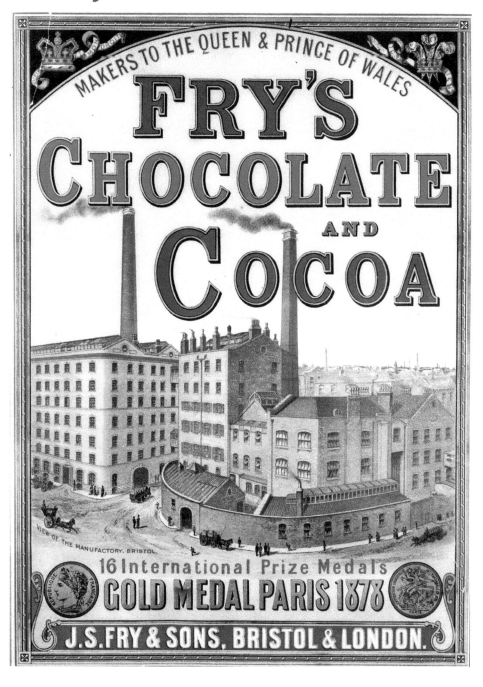

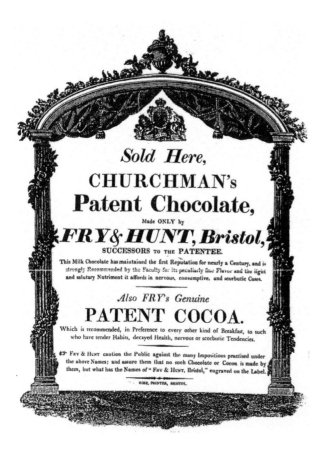

Sold Here,

# CHURCHMAN's
## Patent Chocolate,

Made ONLY by

### FRY & HUNT, Bristol,

SUCCESSORS TO THE PATENTEE.

This Milk Chocolate has maintained the first Reputation for nearly a Century, and is strongly Recommended by the Faculty for its peculiarly fine Flavor and the light and salutary Nutriment it affords in nervous, consumptive, and scorbutic Cases.

*Also FRY's Genuine*

## PATENT COCOA.

Which is recommended, in Preference to every other kind of Breakfast, to such who have tender Habits, decayed Health, nervous or scorbutic Tendencies.

☞ FRY & HUNT caution the Public against the many Imposition practised under the above Names; and assure them that no such Chocolate or Cocoa is made by them, but what has the Names of " FRY & HUNT, Bristol," engraved on the Label.

ROSE, PRINTER, BRISTOL.

---

## PATENT  COCOA,

*GENUINE* and *UNADULTERATED*,

## Made by ANNA FRY and SON,

PATENTEES of *CHURCHMAN's* CHOCOLATE,

### BRISTOL.

THIS Cocoa is recommended by the moft eminent of the Faculty, in Preference to every other Kind of Breakfaft, to fuch who have tender Habits, decayed Health, weak Lungs, or fcorbutic Tendencies, being eafy of Digeftion, affording a fine and light Nourifhment, and greatly correcting the fharp Humours in the Conftitution.

### To make COCOA in the POT.

Take an Ounce of Cocoa, (which is about a common Tea Cupful) boil it in a Pint and a Half of Water for Ten or Fifteen Minutes, then keep it near the Fire to fettle and become fine, after that, decant it off into another Pot for *immediate* Ufe.—It is drank as Coffee, fweetened with a fine moift Sugar, and a little Cream or Milk fhould be added.

It is beft not to be made long before it be drank, left by that Means it lofe Part of its fine Flavour.

N. B. This Cocoa does not require much Boiling; therefore it will go quite as far as any other Sort, with a lefs Quantity of Water than is commonly directed.

## Walter Churchman

The story of Joseph Fry & Sons goes back to 1728 when Walter Churchman opened a grocery shop at Castle Mills and was later granted Letters Patent by George II. Seven monarchs subsequently appointed Fry's to the Royal Household as preferred cocoa and chocolate manufacturers. Churchman's machinery was water powered and his grinding process produced a much smoother beverage than the gritty, chilli-flavoured drink most people were accustomed to. The images show leaflets from the Fry & Hunt days and from Anna Fry's promotion of the health-giving qualities and careful instructions on how to make the perfect cup of cocoa. Cocoa had come to England via the Aztecs and Spain. Cocoa houses such as White's proliferated in London and in other cities, and both cocoa and chocolate became increasingly popular amongst the middle classes in the eighteenth and nineteenth centuries. Imports of quality chocolate started to arrive from France, Switzerland and the Netherlands.

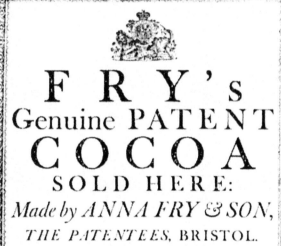

## Joseph Fry Comes to Bristol

Joseph Fry was born in 1728 in Sutton Benger near Chippenham in Wiltshire. His parents were Quakers John and Mary Fry (*née* Storrs). John Fry was a grocer but Joseph chose apothecary as his profession and, after an apprenticeship at Henry Portsmouth's in Basingstoke, set up shop in Small Street, Bristol, in 1753. By 1761, Dr Joseph Fry was not only an apothecary but also an entrepreneur, industrialist and prominent businessman. Together with John Vaughan he bought Walter Churchman's Castle Mills cocoa business which then became Fry, Vaughan & Co. They acquired Churchman's patent rights and his recipes for the manufacture of drinking chocolate. The company moved in 1777 from Newgate Street to upmarket Union Street to tap the wealthy clientele there. Henry Fry's 1766 birth certificate with parents and witnesses is illustrated along with a leaflet announcing Fry's new patent and the perils which await anyone with the temerity to contravene it.

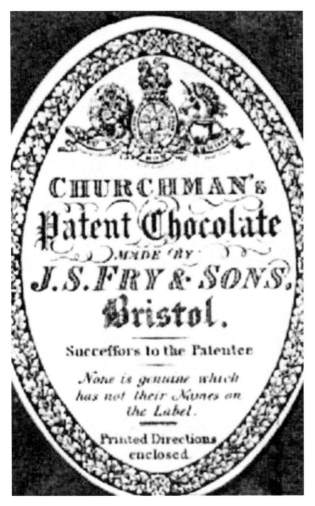

### Anna and Joseph Storrs

In 1787, on Joseph's death, his widow, Anna Fry (*née* Portsmouth) was sole beneficiary, took control and renamed the company Anna Fry & Son. Her brother-in-law, William Storrs Fry, continued to look after the London end of the Fry empire and it was his son, Joseph Fry, who married Norfolk girl Elizabeth Gurney, known better to us as Elizabeth Fry, Quaker prison reformer. The '& Son' in the company name was Anna's son, Joseph Storrs and it was he who was to run the company from 1795. Joseph Storrs immediately industrialised and revolutionised chocolate manufacture in Europe when he introduced a Boulton & Watt steam engine into the manufacturing process in No. 1 Factory, or John Byrt's Room, named after the foreman there: 'the first mechanically driven machine for grinding Cocoa Nibs ... for a long time one of the wonders of Bristol'. A further patent was awarded by George III in 1795. The pictures show an early advert for Caracas cocoa and a cocoa label from the late 1800s – the selling power of the Churchman name was still evident.

## J. S. Fry & Sons

On Anna's death in 1803 a Dr Henry Hunt joined the company thus leading to another re-badging as Fry & Hunt. On Hunt's retirement in 1822 and Joseph Storr's death in 1835 his sons Joseph II, Francis and Richard became partners and the company was renamed J. S. Fry & Sons – by then Britain's largest chocolate producer. To the ill-informed *Morning Chronicle* in 1798, steam-driven chocolate production had been 'a trifling object ... a little article' but in 1835 Fry's were consuming 40 per cent of the cocoa imported into Britain with sales of £12,000 per annum. The illustrations show classic Fry documents: the patents during Anna Fry's reign and two classic adverts reinforcing the health benefits of cocoa, its provenance, purity and appeal to women. A cocoa label from the 1830s is the other illustration.

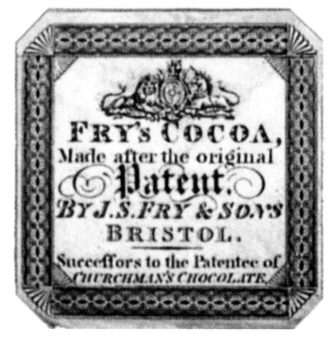

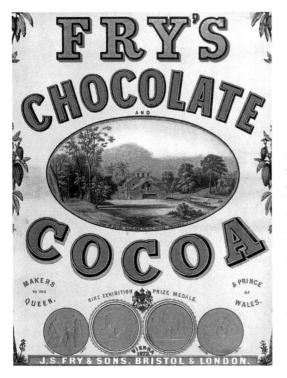

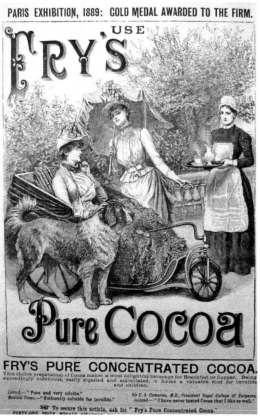

Fry's Cream Stick

1847 was a pivotal year – the year in which Joseph Fry II produced the first chocolate bar which could be *eaten*. French chocolate enjoyed the highest reputation in Britain up to the mid-nineteenth century: anything British simply could not compete. But then Fry's came up with their Cream Stick – the first chocolate confectionery to be produced on an industrial scale. Hitherto, chocolate had exclusively been a drink and a luxury beyond the budgets of most people but this was a 'value for money bar' and marked the start of chocolate as a confectionery for the masses. The poster is from 1875 and shows the Fry plantation in Trinidad and the medals and coveted awards that the company had begun to accumulate. The advertisement below is from the 1889 Christmas issue of *Ladies Pictorial* and features testimonials from the *Lancet*, the *Medical Times* and the President of the Royal College of Surgeons in Ireland. Purity was a key selling point from the start; hitherto most chocolate and cocoa had been adulterated with all manner of things, such as brick dust. Fry immediately enlisted the help of the authoritative medical press to endorse their products' purity, and the health-giving properties of the beverage.

### Fry's Chocolate Cream

The popularity of French chocolate receded to such an extent that Fry's even received a *brevet* appointing them manufacturers of cocoa and chocolate to the Imperial House of Napoleon III (1808–73). It is no coincidence that the first chocolate bar was marketed with the slogan '*chocolate délicieux à manger*'. So, having mechanised chocolate production with steam power and pioneering eating chocolate in 1847, Fry's could claim another first when in 1866 they started production of the direct descendant of Fry's Cream Stick, Fry's Chocolate Cream – a mint fondant cream-filled chocolate bar which was remoulded in 1875 to the shape it retains today. These cards show the children's glee in the Tom Brown 1900 picture below, and the association with the wealthier classes as a rich lady boards her motor car in Piccadilly Circus having bought a consignment of Fry's chocolates (left).

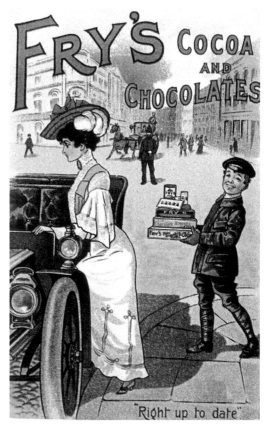

"Right up to date"

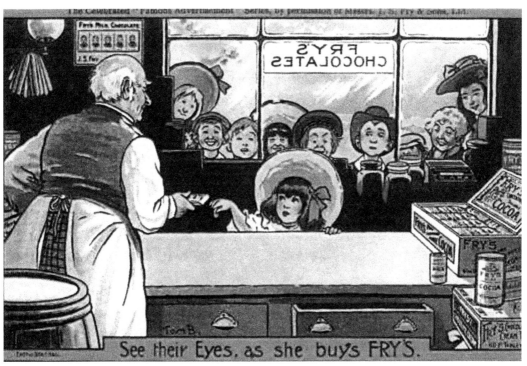

See their Eyes, as she buys FRY'S.

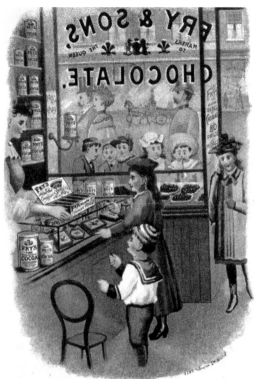

·J·S·FRY&SONS. BRISTOL, LONDON &SYDNEY

### Fry's Milk Chocolate

Fry's Pure Concentrated Cocoa was an immediate success on its launch in 1883, followed later by Breakfast Cocoa. Fry's Milk Chocolate was launched in 1902 – later rechristened Fry's Five Boys. Orange Cream and Peppermint Cream followed with Fry's Five Centre in 1934 (orange, raspberry, lime, strawberry and pineapple). Output of Fry's Chocolate Cream exceeded half a million units per day at one point. The iconic foil wrapping and blue label was introduced in 1925. Before it became Fry's Chocolate Cream it was called Fry's Cream Stick, Fry's Cream Tablettes and Fry's Cream Tablets. These delightful cards show noses up against the window, envy generated by Fry chocolate in 1895, and the scheming lengths to which grown men will go to woo women. Export markets, especially the Empire, were becoming important; Fry are here advertising their Sydney factory.

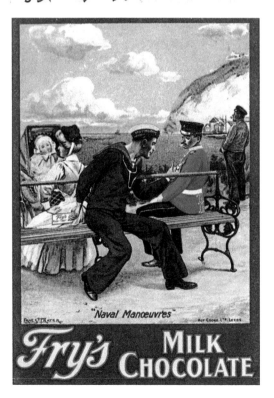

"Naval Manoeuvres"

Fry's MILK CHOCOLATE

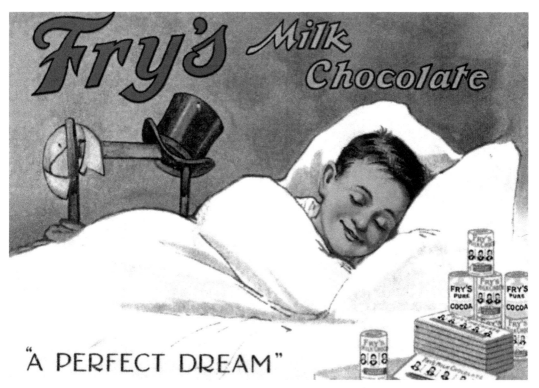

## "A PERFECT DREAM"

### Fry's Five Boys

In 1835 there were sixty-five employees; by 1913 there were more than 4,000. The posters here show how Fry aimed at all classes of children – from an Eton schoolboy in perfect heaven (see also page 16) to a somewhat less literate little girl similarly delighted by Fry's chocolates. On the next page we meet Five Boys: the iconic design featured sequential facial expressions ranging from 'Desperation', 'Pacification', 'Expectation', 'Acclamation' and 'Realization'. The Five Boys images came from Conrad Penrose Fry's purchase of the rights to some pictures an American photographer called Poulton had taken of his son Lindsay. Conrad was also responsible for the famous Hello Daddy advertisements. 'Desperation' had the dubious privilege of having his father tie a neckerchief soaked with ammonia round his neck to achieve genuine desperation.

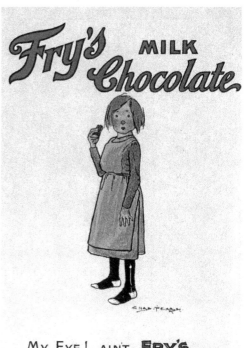

MY EYE! AIN'T **FRY'S** MILK CHOCOLATE NICE!

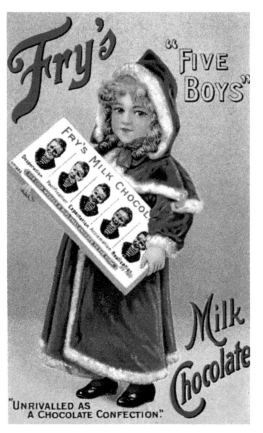

## Specialties of the House

Chocolate Cream was the first of many 'Specialties of the House', to be followed by Crunchie; Punch (which came in three flavours: Full Cream, Milk Chocolate, Delicious Caramel and Milky Fudge – output was millions per month); Caramets – produced in a pack 'ideal for both pocket and handbag'; Crunch Block; Turkish Delight 'exquisitely flavoured with genuine Otto of Roses'. The illustrations show the Coronation of George V on 23 June 1911, and the Five Boys milk chocolate. *The Times* reported on Fry's royal connections at the time; apart from Victoria, Edward VII and George V and Queen Alexandra they list honours from Queen Margherita of Italy, the King and Queen of Spain and the King and Queen of the Hellenes, as well as the 1867 Special Brevet from Emperor Napoleon III appointing them Manufacturers of Cocoa and Chocolate to the Imperial House.

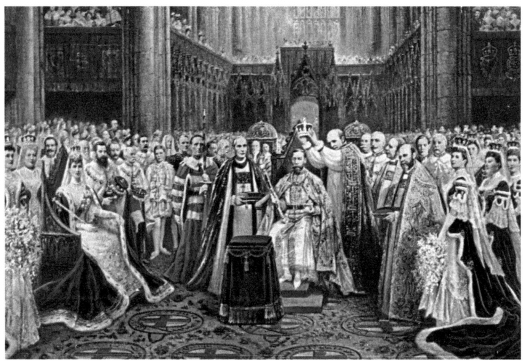

## Chocolate Boxes

In 1868, Fry's highly decorated chocolate boxes were launched, full of assorted chocolates, very popular at Christmas and sporting a vast array of colourful designs. The most sought-after were Double Milk Assortment: eleven different chocolates with a double milk chocolate coating; Sandwich Assortment: separated layers of milk and dark chocolate in one block; Silver Lining Assortment: this contained Cherry in Fondant; Hazelnut Fudge and Fruit Nougatine. Market research was an important facet of Fry's marketing right from the start: the colour of the cups for these chocolates was chosen by 85 per cent of informants. The pictures show chocolate cigarettes from the First World War and a *Strand Magazine* advert proudly listing the all-important roll call of British monarchs who have enjoyed Fry cocoa and chocolate. The sale of chocolate cigarettes remains controversial and is banned in a number of countries. Despite the possibility that their consumption may in time lead to the use of tobacco cigarettes, they remain available, although their name is often changed in these more sensitive modern times to 'candy sticks'. Most of the confectioners in the early twentieth century manufactured chocolate cigarettes or cigars of one kind or another, including Rowntree's, Dunn's and Maynard's.

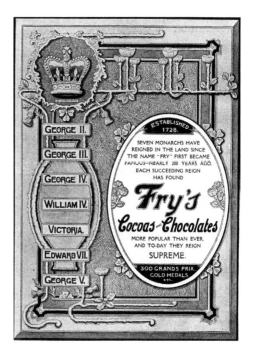

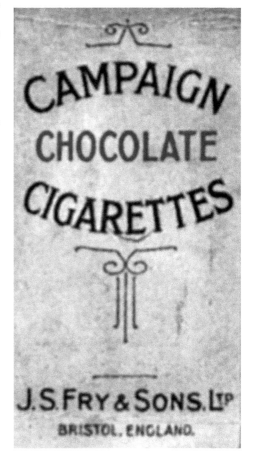

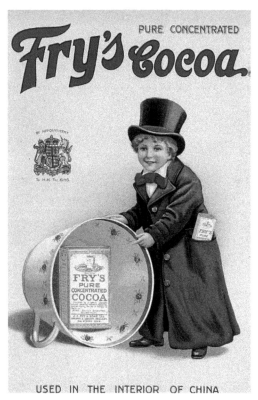

PURE CONCENTRATED

**Fry's Cocoa.**

FRY'S PURE CONCENTRATED COCOA

USED IN THE INTERIOR OF CHINA

CONFECTIONERY JOURNAL

**FRY'S 1924 EASTER NOVELTIES**

FOR PARTICULARS SEE ADVERTISEMENT IN THIS ISSUE

### The First British Easter Egg

By the 1870s Fry's were selling 220 different products, including the first British Easter egg, from 1873. In 1914 they launched their first milk chocolate bar, Fry's Milk Chocolate (Five Boys), five years after Cadbury's Dairy Milk; their popular and enduring Fry's Turkish Bar came in 1914. The advertisement shows that its output was by no means confined to just Easter eggs at Easter; all manner of beast, fowl and fish came off the production line. The first Easter eggs – largely stripped of any religious significance – probably originated in France and Germany in the early 1800s and were solid, as moulding techniques had not then been perfected. The Germans developed the 'crocodile' finish which formed a crazy paving finish on the smooth surface of the egg and hid minor imperfections. The poster shows how Fry's exports extended even then to the Chinese interior. Joseph Storrs Fry II died in 1913, blind and a millionaire (his estate was worth £1.35 million),with over two hundred benefactors named in his will, including his employees who received £42,000 between them.

### Fry and Captain Scott

Fry's sponsored Captain Robert Falcon Scott's expedition to the Antarctica in 1910 with a £1,000 donation, an early shrewd marketing move which elicited the striking poster here and the following priceless testimonial from Captain Scott: 'Messrs. J. S. Fry & Sons supplied our Cocoa, sledging and fancy chocolate, delicious comforts excellently packed and always in good condition ... Crunching those elaborate chocolates brought one nearer to civilisation than anything we experienced sledging.' The French Fry postcard was sent from a BFPO address to a British nurse in 1921 with this perfunctory message from 'Philip' on HMS *Puncher* docked in Port Said: 'we are glad you are enjoying yourself but we would like it best if you were here'. Again, the publicity shows the pains Fry was at to emphasise the stamina- and health-giving qualities in their products, with a hint of the brave and the beautiful along the way.

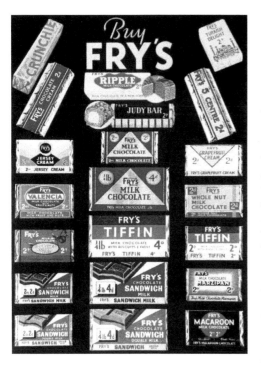

## The Merger with Cadbury

In the years leading up to the war, Fry's suffered badly from a lack of investment; their reputation and market share suffered as a result – plummeting from 84 per cent in 1870 to 38 per cent in 1910 – mainly due to the resurgent firms of Cadbury and Rowntree. In 1918, Fry merged with Cadbury to become part of the holding company that was the British Cocoa & Chocolate Company: Fry and Cadbury were subsidiaries. Cadbury's assets had been assessed as three times that of Fry's, thus illustrating the relative strengths of the two companies. Nevertheless, both companies more or less retained their individual identities, marketing and branding their respective products independently.

The colour poster shows the range of Fry products available in the 1930s, while the *Strand Magazine* advertisement urges the businessman to take Fry's cocoa to set himself up for the busy day ahead. In this respect he was following in the tradition of Casanova and Samuel Pepys who, on 24 April 1661, used it as a cure for a hangover after Charles II's coronation, after waking up 'with my head in a sad taking through last night's drink which I am sorry for. So rose and went out with Mr Creede to drink our morning draft, which he did give me chocolate to settle my stomach.' In October 1662 he drank it with Mr Creede and Captain Ferrers in Westmister Hall. On 3 May 1664 Pepys was 'Up, and being ready went by agreement to Mr Bland's and then drank my morning draft in good Choclatte, and slabbering my band, sent home for another.' On 24 November 1664 he tells us 'Up and to the office, where all the morning busy answering of people. About noon out with Commisioner Pett, and he and I to a coffee house to drink Jocolatte, very good.'

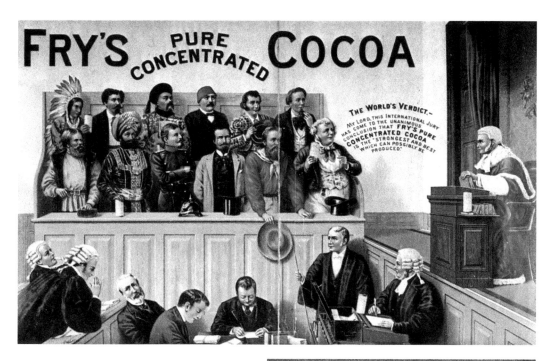

## Somerdale

Major Egbert (Bertie) Cadbury joined the Fry part of the business and he and Cecil Fry engineered the move to a purpose-built factory on 222 acres in Somerdale, Keynsham Hams, inbetween the River Avon and the London–Bristol main line, just off the A4, in 1923. The 1920s saw the development of industrialisation and more profitable mass production successfully facilitated by the new factory. Global markets and associations with the professions are above with the mildly suggestive advertisement on the right by Harold Fanshaw, published in *Cricket Illustrated*.

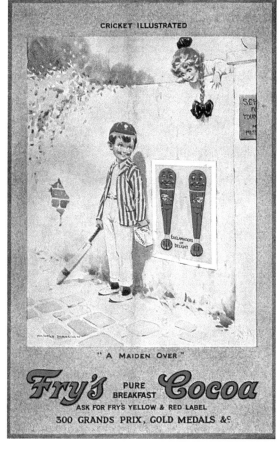

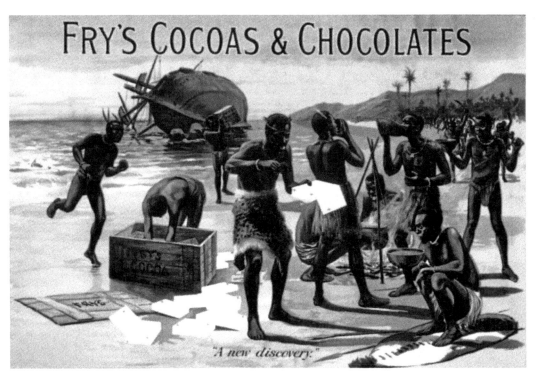

**FRY'S COCOAS & CHOCOLATES**

"A new discovery."

FRY'S COCOA

**FRY'S PURE CONCENTRATED COCOA**

makes a delicious beverage for Breakfast or Supper, and owing to its nutritious and sustaining properties, will be found eminently suited for those who require a light yet strengthening beverage.

*Half a tea-spoonful is sufficient to make a Cup of most delicious Cocoa.*

☞ **TO SECURE THIS ARTICLE ASK FOR "FRY'S PURE CONCENTRATED COCOA."**

Gold Medal, Paris, 1889. Forty-three Prize Medals awarded to the Makers,

**J. S. FRY & SONS, BRISTOL, LONDON, AND SYDNEY, N.S.W.**

'Sunlit Meadows'

The move from Union Street was a gradual affair, lasting twelve years until 1934 when 6,000 women and men were on the payroll. The factory itself was set in parkland with poplar and chestnut trees, flower beds and lawns. *Fry's of Bristol*, an early corporate booklet, tells us that 'the Cocoa department looks on to woodland slopes and sunlit meadows' and gives us a flavour of the bucolic setting that was Somerdale. Another early booklet, *Into the Open Country*, provides the company's mission statement and the corporate ethos back then: 'Fry's have kept before them two guiding principles; one, giving the public the best possible value in cocoa and chocolate manufactured under the best possible conditions; the other, of giving the workpeople the best facilities for recreation and happiness.' The shipwreck poster above is somewhat ironic in that it was black slaves who were responsible for much of the world's cocoa production during the nineteenth century.

## The Quaker Connection

Both the Fry and Cadbury families were of course Quakers and, like the Rowntrees in York, they were at pains to provide their workers with a clean, safe and pleasant working environment. Joseph Storrs II was particularly philanthropic. He habitually visited sick workers at their homes, provided sanitary and comfortable housing along with free educational, social and recreational facilities and benefits. The company employed a nurse and a doctor, ran 'Continuation Classes' (further education) for the girls, provided a gym with instructors, football, tennis, cricket and bowls and set up the Operatic Society, the Camera Club, the Debating and Dramatic Societies. Girls leaving to get married received a Bible and a copy of *Mrs Beeton's Book of Household Management*. The adverts show that Fry chocolate nourishes the mind and the body: *mens sana in corpore sano*.

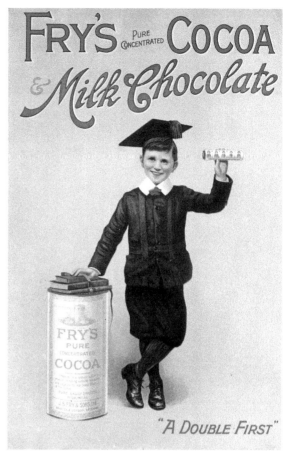

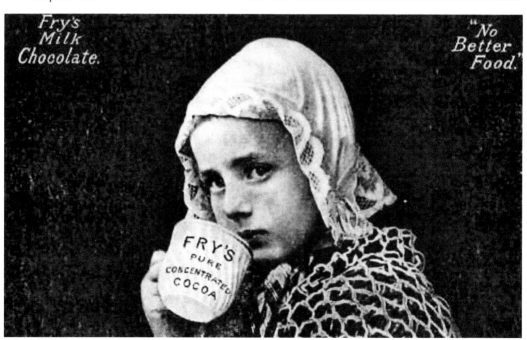

### Do Not Eat the Chocolate ... Or Sing

Discipline, on both sides of the Fry factory gates, was strict as extracts from the 1851 company rules show: 'All Day and Piece Workers are expected to attend the scripture reading at a quarter to 9 am. As soon as the bell rings for the reading, every person to go immediately into the room and the Timekeeper to bolt the door five minutes after the bell has rung ... no person to use or eat any chocolate ... no person to sing or make noises in the premises ...' Despite his wealth, Joseph Storrs was as modest and frugal as he was paternal. He lived in rented accommodation for much of his life; he only bought when his landlord put the premises up for sale, taking him on as his butler. His greatest pleasure was taking morning prayers at the factory. The beautiful 1921 advertisement published in *The Sphere* shows that chocolate is very much part of any child's holiday experience.

*Reflections*

NO HOLIDAY IS COMPLETE WITHOUT

*Fry's Chocolate*

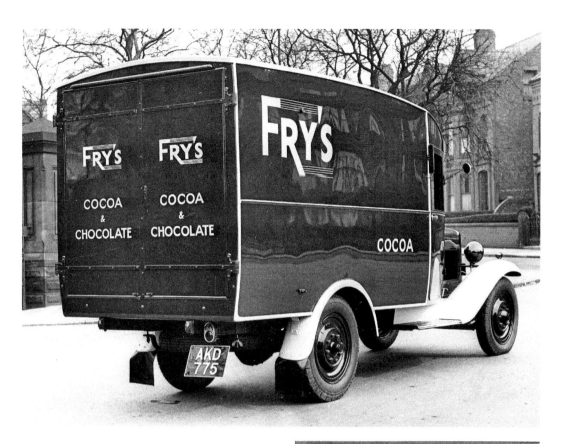

## Go to the Pub at Your Peril...

'It is particularly requested that every person, whether on the premises or at other places, be at all times strictly sober and that no one be in the habit of frequenting Public Houses or Beer Shops; any person known to do so will not be regarded by their employer with confidence and this knowledge will at any time be considered good reason for discharging a man or a girl ... all unnecessary conversation and familiarity between men and girls is strictly prohibited.' The classic Fry adverts show the universality of chocolate, the global harmony it creates, how its appeal crosses all classes; the desire for chocolate – and the need to save up!

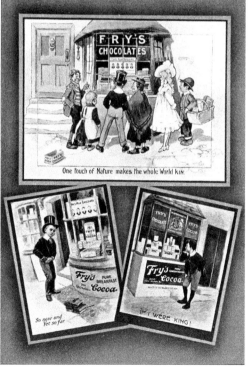

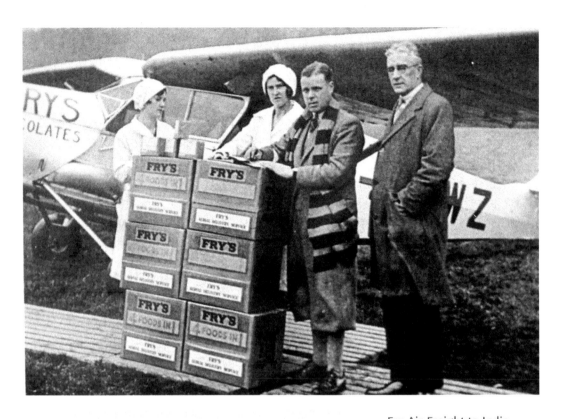

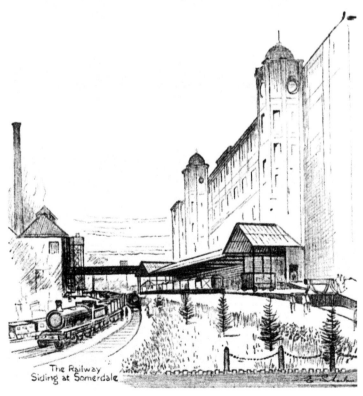

**Fry Air Freight to India**
The pencil drawing is of the Somerdale railway siding by E. Sharland, published in the *Bicentenary Number of Fry's Works Magazine 1728–1928*. The photograph depicts a pilot signing for an India-bound consignment of Fry's cocoa on the maiden flight in September 1932 from Bristol Airport. Somerdale was connected to Bristol and nearby suburbs by railway – this, of course, facilitated the import of raw materials and the export of finished products.

The Railway
Siding at Somerdale

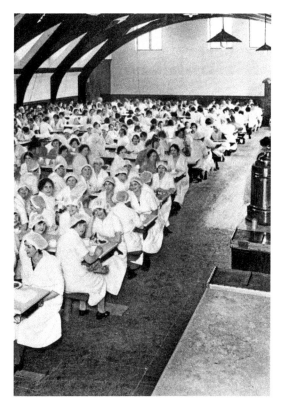

### Fry Women

Up until the First World War women were a rare sight in the Fry offices; this extract from the *Bicentenary Number* quaintly describes the changes which were taking place: 'the sweeping changes which took place in the Offices ... made it necessary for the Firm not only to retain the ladies they had but to engage a large number of others. And so Eve came to our offices ... at first we were inclined not to take her very seriously. We thought that after a few days' steady work Eve would be probably knocked up and absent with an attack of hysteria, the megrims or the vapours. Eve had nothing of the sort. She did her work well and kept on doing it ... her smile, her shingle and her stockings, have caused the commercial desert to blossom as the rose.' Plenty of women in these photographs: in the dining room and in a Continuation Class. The Continuation Classes epitomised the Quaker ethos and its insistence on education for all; it was, not surprisingly, shared by Cadbury's and Rowntree's, both of whom set up Continuation Classes in their factories to ensure that girls and boys leaving school so early were not denied the fruits of learning on account of the need to work. The Cadburys and Rowntrees taught in their local adult schools, while Joseph Storrs had close connections with the local blind school and University College Bristol, later Bristol University. At Fry, the girls school had an average of 600 attendees.

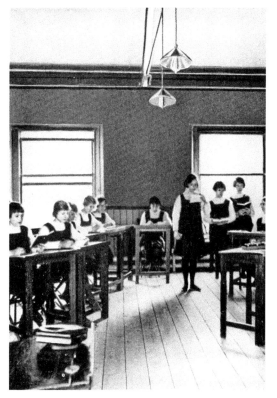

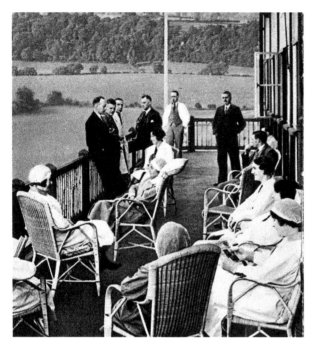

*Fry's Works Magazine Bicentenary Number, 1728–1928*

This *festschrift* features an article by Lord Riddell (editor of the *News of the World* and friend of David Lloyd George) entitled 'The Chocolate Age'. In it he captures the huge popularity of chocolate in the late twenties reflecting the fact that chocolate was no longer a luxury but was increasingly affordable by more and more people: 'Everyone eats more – women and children because they have more money and more presents than they did, and men because they drink [alcohol] less. I am told that even dogs are taking to chocolate ... any man who takes a lady to the theatre and neglects to give her chocolate, if she so desires, may expect the censure implied by black looks.' The pictures show Fry employees enjoying an after-lunch break on the dining hall verandah. The poster shows how integral Fry products were now to the traditional British picnic.

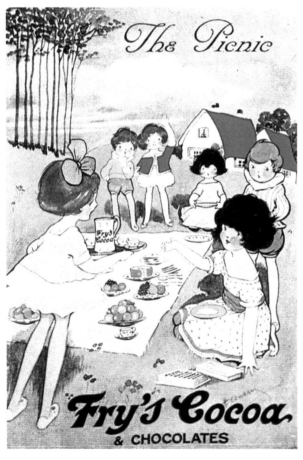

## Five Boys

Five Boys and Five Centre feature in these classic advertisements, the latter from 1905 – see pages 12 and 13 top. Long service was a common feature at Fry's. Three families in particular stand out: twelve members of the Buckland family recorded 278 years between them, fifteen Sixsmiths racked up 238 years, and the eleven Leslies totalled 227 years before the last one clocked off for the last time. Chocolate may have been the most important business for the Fry family, but it was by no means the only one in which they have left a significant mark. Joseph Fry was a successful printer and typesetter – 'typefounders to the Prince Regent' no less, and inventor of the Baskerville typeface; still one of the most popular fonts today and used by style gurus like Sir Terence Conran. Joseph's alkali works in Battersea developed into Fry, Fripp & Co. and served the candle industry in Bristol, before eventually being bought by Lever Bros.

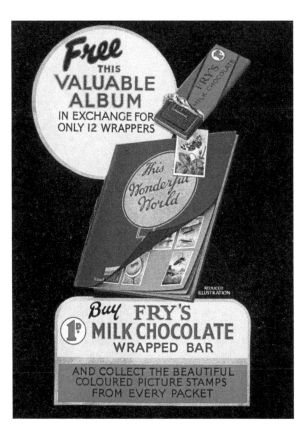

Cream Eggs
The illustration below shows a poster for Cream Eggs with Pan entrancing the local sheep – a suitably bucolic scene in tune with the healthy properties of Fry's chocolate and the bewitching effect of Cream Eggs. The other is a promotional advert for the trade cards and album which Fry (and all the other manufacturers) ran to encourage collecting and completism through the purchase of chocolate.

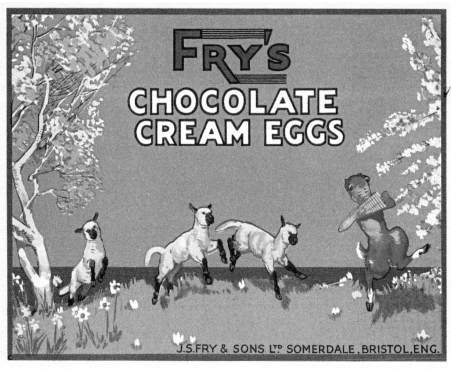

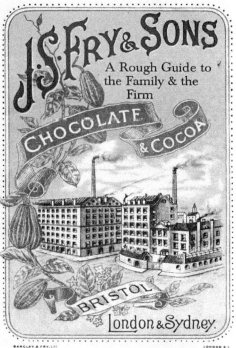

*A Rough Guide to the Family and Firm*
The covers of this 100-page book on the Fry family, published in 2010 by the Frenchay Village Museum. It traces the wider Fry family, from 1728 to the late twentieth century, describing the resourcefulness of many of its members taking in their huge achievements in many industries: chocolate and cocoa manufacture of course but also typography and printing, racing cars, soap, porcelain, oil, boat building and vacuum cleaners. The front cover shows the (modified) 1900 Fry price list; the back cover includes the famous Five Boys advertisement, Fry's Chocolate Cream 1870, Assorted Chocolate Varieties box, a model of the Freikaiserwagen and a Cyclon vacuum cleaner. The Freikaiserwagen (Frei = Fry) was the racing car first built by David and Hugh Fry in 1936 using pioneering rear suspension technology and siting the engine behind the driver – both standards today in motor sport. The Cyclon was the forerunner of the Dyson vacuum cleaner, developed under the auspices of the Fry Products Company run by Jeremy Fry in the 1960s.

Over a period of some 250 years, seven generations the remarkable Fry family were pioneers in many fields from chocolate making, to record-breaking racing cars, by way of soap, porcelain, international affairs, a university, the oil industry, boat building, and vacuum cleaners.

This book gives a glimpse into the lives of some of them, and tells of their achievements in many fields, but principally that of making chocolate.

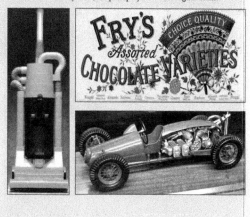

29

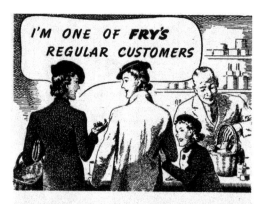

Mrs. F: I'm looking for something good to drink, and not too dear—a bit of a problem nowadays.

Mrs. M: Fry's is what you want. 'Get it as regular as the rations,' is my motto!

Mrs. F: If I can do that too it will save a lot of bother.

Mrs. M: The grocer always says I'm one of Fry's most regular customers, and it's been well worth it. Peace or war, Fry's is just the nourishing food drink that we need.

Mrs. F: I'm going to take your tip and do the same. I know the kiddies will thank me for it—they always love anything with a real chocolate flavour, and now I can plan to give it them regularly.

# FRY'S COCOA

*The food you should buy* EVERY WEEK

5D. PER QTR. LB. • 9½D. PER HALF LB.

## FRY'S COCOA

*and all's well*

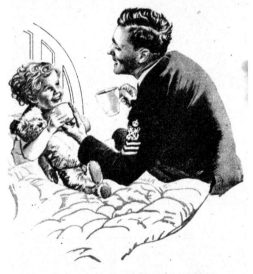

5" QTR LB • 9½" HALF LB

THE FAMILY FOOD DRINK WITH THE *REAL* CHOCOLATE FLAVOUR

## Fry's War Efforts

In 1780 Fry was commissioned to supply the Royal Navy with a ration of chocolate in cocoa slab form for its sailors to replace rum and to provide them with something a little more nutritious to go with their ship's biscuit. In the 1850s Fry's tins were sent to the troops fighting in the Crimean War. Adverts from 1942 target mothers and fathers to reassure them of the nutritional and reassuring benefits of Fry's cocoa to their children. 1928 was a very special year for Fry, it being the 200th anniversary of the firm. The special edition of the *Works Magazine* featured articles by such luminaries as Ernest Bevin, the General Secretary of the Transport and General Workers Union, a leather-bound, gilt-tooled and edged edition for directors, a special medal for all employees and pensioners struck by the Royal mint – one of fine gold in a black moroccan case presented to George V; 450 silver and 6,000 bronze respectively. Total cost of the work was £1,460 10s 6d. In addition everyone got an extra week's pay or pension.

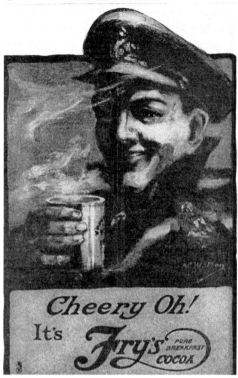

## The Bristol Aeroplane Company

Fry's were able to make a positive contribution to the Second World War effort by giving up factory floor space to the production of Rolls-Royce Merlin engines. Somerdale became the Bristol Aeroplane Company. The *Strand Magazine* advertisements extol the contribution that Fry's cocoa makes to the war effort both at home and away on active service. The Continuation Classes taught English, First Aid, Hygiene, Cooking, Laundry, Dressmaking and Civics – designed, presumably, to produce good citizens as well as good workers. There was also Marlborough House girls' club, which held social events such as whist, Fry's Bristol 40th Girl Guides, and amateur dramatics in the form of the Old Vic Shakespeare Society. On the boys' side was the Cocoa Tree Club, named after the famous chocolate house in St James's.

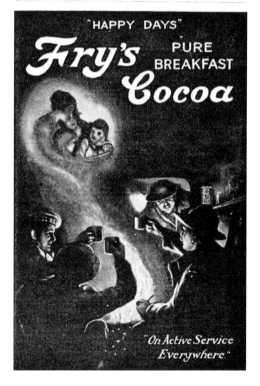

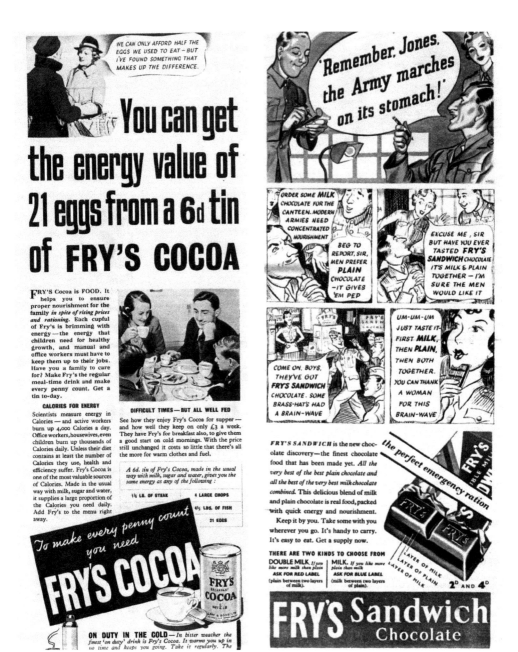

Fry's Sandwich – Emergency Rations

Two advertisements from 1939 and 1940 in *The Picture Post*. The first appeals to the thrifty housewife looking for an inexpensive energy substitute to replace expensive and scarce eggs, steak, fish and lamb chops. The second is aimed at the troops and civilians, vaunting as it does the blend of milk and plain chocolate that is Fry's Sandwich.

Snaps from Nigeria and Coomassie
Published originally in the *1928 Bicentenary Number* of *Fry's Works Magazine* these fascinating pictures show aspects of life at the Cadbury-Fry plantations in Nigeria. Clockwise from top left: a washing pool, Egbeda Street, the Agency's premises in Coomassie 1916, buying cocoa in Ibadan and the agency in 1928. 'Here Comes the Chocolate Major' was a song composed by Bennett Scott and sung by Mr G. H. Elliott (1882–1962). The text, from the *Strand Magazine*, on the verso reads: 'Mr G. H. Elliott, one of the most brilliant stars of the music-hall world, has had other associations with chocolate than that embodied in his make-up, which has earned him the title of the "Chocolate-covered Coon" ... presenting packets of chocolate for children in numerous charitable institutions.'

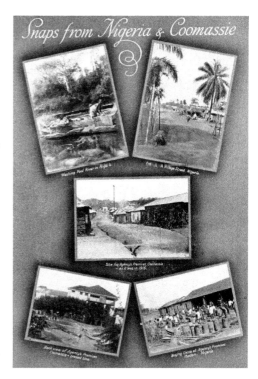

Snaps from Nigeria & Coomassie

# Here comes the Chocolate Major

WRITTEN BY A. J. MILLS.  As sung by **Mr. G. H. ELLIOTT.**  COMPOSED BY BENNETT SCOTT.

QUICK March! there comes a regiment of soldiers,
  Gaily they stride,
Quick March! and all the pretty girls come out
  To watch them with pride;
Dress'd in his choc'late colour'd uniform
  The Major's on show,
If you should say, "What's all the fuss about?"
  "Good gracious, don't you know?"
  Here comes the Chocolate Major,
  Here comes the soldier boy,
  He's a lady killer, sweeter than vanilla,
  And when they meet him—oh! they want to eat him.
  Here comes the Chocolate Major
  Dressed in his gay attire.
  He's a dream-supreme,—
  **HE'S FRY'S BEST CHOC'LATE CREAM**
  All the nice girls admire.

"Eyes Right!" you'll hear the dandy Major shouting,
  As on they go,
Eyes Right! will set the ladies' hearts a' beating faster,
  That's so;
They can't resist the Choc'late Major when he singles
  Them out;
And when they hear the rattle of the drums
  The girls in chorus shout.
*Chorus.*
  Down town, you'll see the colour'd flags and banners
  Waving on high.
  Down town, as merrily the Choc'late Major
  Goes marching by;
  Left! Right! each military Johnnie looks
  A real la-di-da,
  And all the girls will wave their handkerchiefs
  And gaily shout, "Hurrah!"
*Chorus.*
  COPYRIGHT.
  Words and Music published by The Star Music Publishing Co. Ltd.,
  51 High Street, New Oxford Street, London, W.C.
  OF ALL MUSIC SELLERS, 6D. EACH.

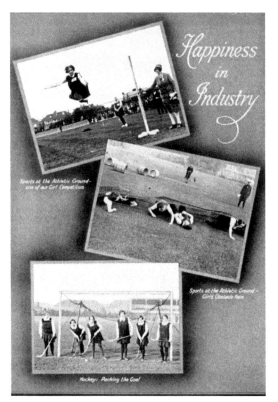

Happiness in Industry

The photograph here is one of the many pages showing the sporting and cultural facilities open to workers at Fry's. They too were published originally in the *1928 Bicentenary Number* and show (clockwise from top) a Day Continuation School classroom, dinner-hour activities at Somerdale, players in the Happy Man Continuation School Open Day in 1927, and swimming in the Avon at Somerdale. The picture above shows girls' sports on the Athletic Ground. Fry's original pre-Somerdale athletics ground, which also featured a cycling track, was used by Gloucestershire CC for their home games. On the move to Keynsham the ground was sold to the cricketers and remains the County Ground to this day.

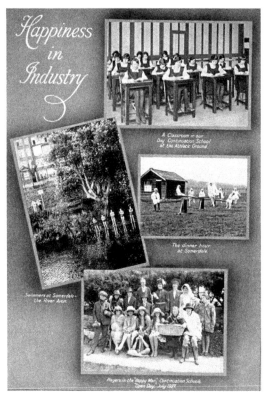

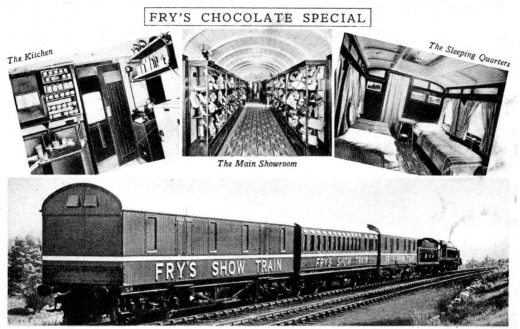

*The Kitchen*

*The Main Showroom*

*The Sleeping Quarters*

*Issued by the House of Fry, Cocoa and Chocolate Manufacturers, Somerdale in Somerset*

Fry's Show Train
Launched in 1933, the Show Train was described as 'a novel development in British salesmanship' and comprised three coaches converted from a restaurant car and two theatre scenery vans. One coach was fitted out for the exhibitions with twelve three-tiered show cases which displayed over 200 Fry's products; the restaurant car was fitted out as a 'tastefully decorated' mahogany panelled tea room with eight Lloyd Loom tables and twenty chairs; it also contained the sleeping quarters for the two representatives. The third car housed the electrical plant to power all of the lights. The photographs show the blue and gold liveried Show Train and a scene from the loading deck in the railway siding.

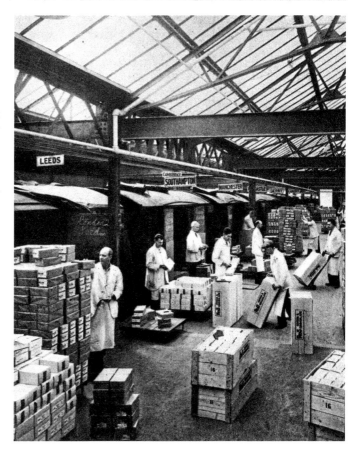

35

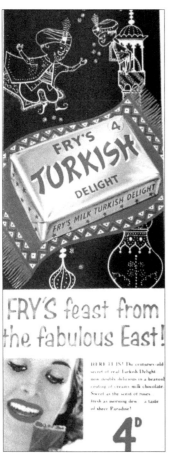

A Gaggle of Giggling Girls

Late 1950s magazine advertisements showing the liberating, alluring and exotic qualities of Fry's chocolates. Thousands of staff benefitted from the rail link with what was effectively an exclusive commuter line. Russell Leitch's comments on this daily commute in his *The Railways of Keynsham* make interesting reading: 'one drew a deep breath and waited for the worst. The door opened, a gaggle of giggling gregarious girls rapidly fell in to the compartment ... and another load of Fry's Angels were on their way home ... the gossip and laughter were non-stop, for the Angels were predominantly girls ... relieving themselves of the boredom of putting squiggles on chocolates, or whatever, for hours on end.'

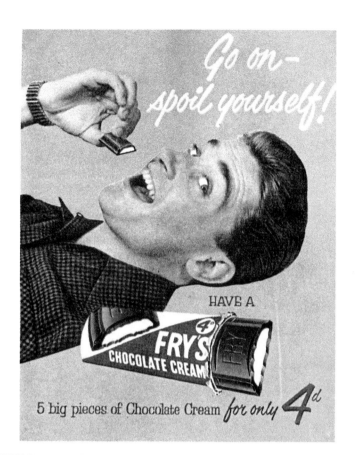

**Fry's Chocolate Cream**
Adverts for Fry's Chocolate Cream in *Reader's Digest* in the late 1950s.

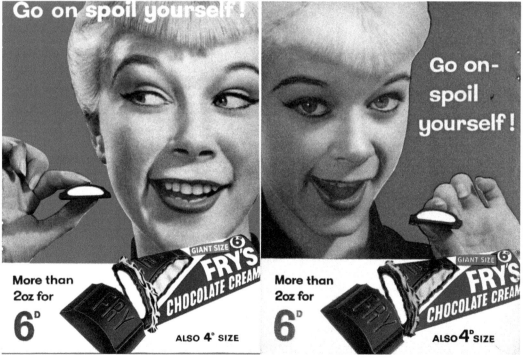

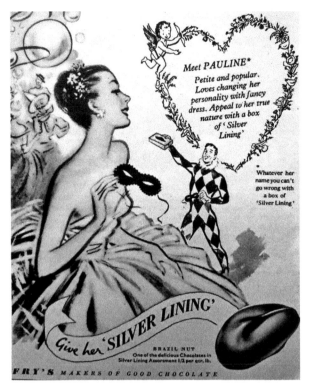

## Silver Lining Assortment

A 1960s advert for Fry's Silver Lining assortment appealing not just to middle class women but also to the men trying to appeal to women. Note the insistence on the interchangeability of the woman's name. The woman gets her money's worth in the advert for *Punch*. Somerdale is still home to the Fry Club, a sports and leisure club with 600 members. In January 2012 it was announced that Kraft would sell Somerdale to Taylor Wimpey for £35 million. The sale is bound by conditions, one of which is to 'reprovide' for the club; others include redeveloping the site for mixed-use, which could mean 600 homes and 20,000 sq. metres of commercial space and 900 jobs. Roads in the development will have to be named after the Frys.

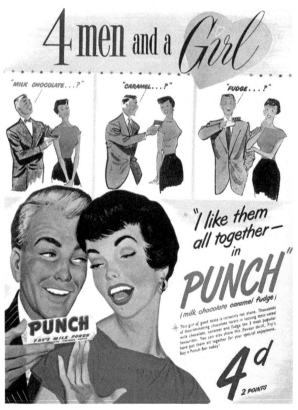

### Local Competition: Packer & Co.

Fry was not always the only chocolate maker in Bristol: H. J. Packer, a former Fry's employee, began trading in 1881, making chocolate from his house in Armoury Square, under the name of Packer & Co. The workforce comprised Packer's sister and brother, and a Miss Lily Brown who was paid 2s 6d a week. The plant consisted of a kitchen fire and a paraffin lamp, two saucepans and a small pan for making the chocolate and the cream centres. Sugar was bought in 14-lb loads and the finished chocolates were delivered by hand. The photographs show caramel production at Elizabeth Shaw in the 1960s, the company which evolved from Packer's, and an early Packer poster.

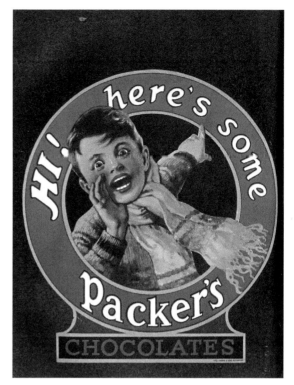

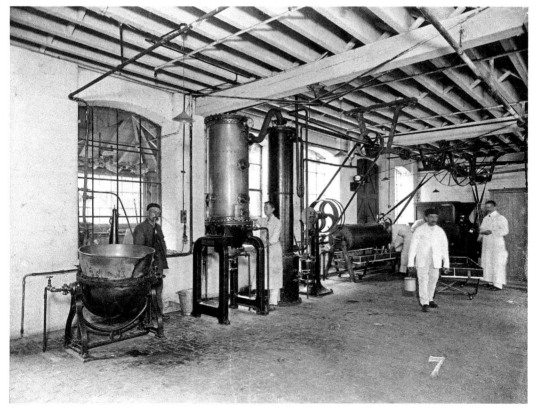

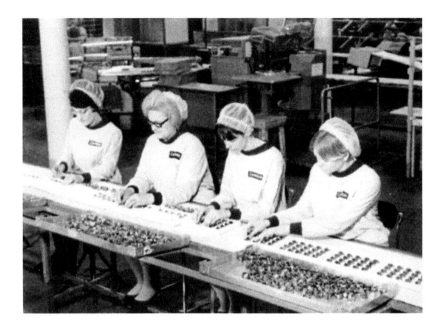

### Greenbank

In 1884 Packer hired H. J. Burrows – another former Fry's employee – and when the partnership was dissolved in 1885, Burrows became owner of the business. The next year saw the twenty-year-old Bruce Cole pay Burrows £950 for all plant, stock, debts and goodwill. Business began to boom from 1896 and in 1901 the company moved to a specially commissioned, high-specification factory at Greenbank. The business grew and between 1903 and 1912 sales increased by 250 per cent. Their strategy to sell 'Two Ounces a Penny' chocolate – good quality chocolates at a low price a child could afford – had taken off. Packer's Chocolate Mixtures was one of their main lines. The packing and chocolate making at Packer's in the 1920s.

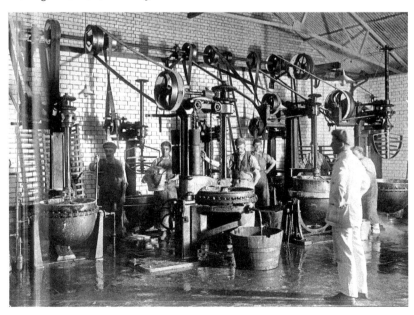

# CADBURY

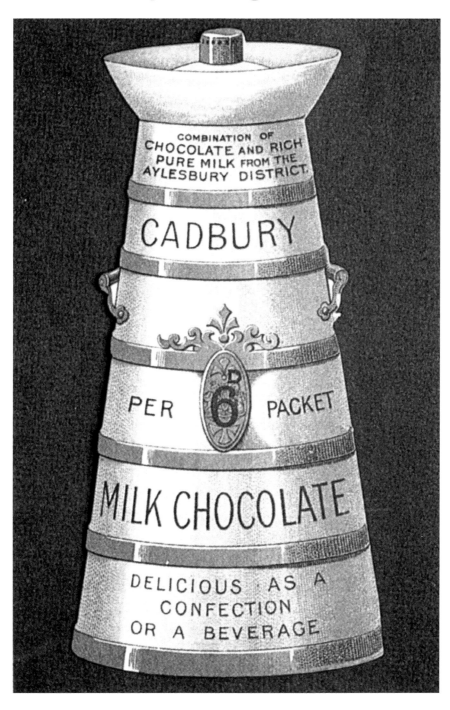

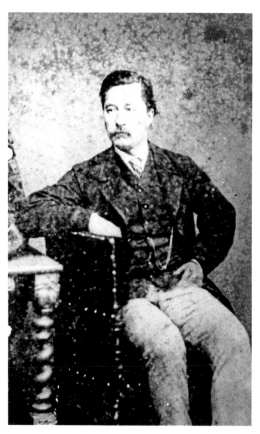

**Chinaman in a Bull Street Shop**
In 1824, John Cadbury, son of a prosperous Quaker, set up shop selling tea, coffee and sixteen varieties of drinking chocolate at 93 Bull Street, Birmingham, after completing an apprenticeship in London at the Sanderson, Fox & Company teahouse. The shop was certainly remarkable: it featured an eye-catching window filled with Chinese vases and figures and, appropriately for a tea merchant's, a Chinese shop assistant dressed in full Chinese regalia. The pictures show John Cadbury (1801–89) on the left and George Cadbury (1839–1922).

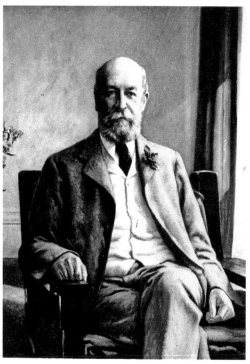

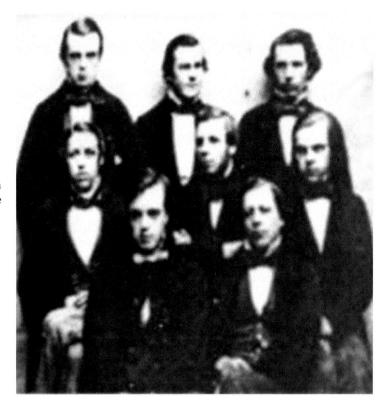

**George Cadbury at Rowntree's**
Cadbury then moved to an old malt house in Crooked Lane where he perfected coffee bean grinding to produce cocoa, and then to a factory in Bridge Street. John's brother, Benjamin, joined and the company became known as Cadbury Brothers of Birmingham. John Cadbury's sons, Richard and George, took over the business in 1861 – still modest with about ten employees and not at all successful. George joined in 1857 after a three-year apprenticeship with Rowntree's grocery business in Pavement, York. George Cadbury is pictured here at Rowntree's, middle right with Joseph Rowntree to his right.

THE CROOKED LANE WAREHOUSE.

be his study to deserve.

Birmingham, March 1, 1824.

## TEA AND COFFEE WAREHOUSE,
### No. 93, BULL-STREET.

JOHN CADBURY, Tea Dealer and Coffee Roaster, most respectfully announces to his Friends and the Public in general, that he intends commencing business on the 4th of the present month in the above line, and he trusts, by assiduous attention to the interest of those who may favour him with their commands, to merit their support, conscious that this can only be obtained by the sale of pure and genuine articles, which it will be his constant endeavour to supply them with.

Having had the advantage of residing a considerable time in a wholesale tea warehouse of the first eminence in London, and of examining the teas in the East India Company's warehouses, and attending the sales, likewise of frequenting the Coffee-market, he is enabled to procure these articles equal to any house in the trade, and consequently can offer them on the most advantageous terms.

He will regularly be furnished with Coffees of the finest quality, and a supply will be kept fresh roasted, which alone can insure a fine and delicate flavour.

J. C. is desirous of introducing to particular notice Cocoa Nibs, prepared by himself, an article affording a most nutritious beverage for breakfast.

☞ Chocolate, Patent Cocoa, Hops, Mustard, &c. of very superior quality.

No. 93, Bull-street, 1st of 3d mo. 1824.

## THE ROYAL LEWISIAN SYSTEM OF
### WRITING,

the im̅ and especia̅ Patronage of his

## The Indolent and Wayward Need Not Apply

George would have had no doubts concerning the rigour of his apprenticeship. The rules of the shop there were uncompromising as set out in a memorandum from Joseph Rowntree Snr: 'The object of the Pavement establishment is business. The young men who enter it ... are expected to contribute ... in making it successful ... it affords a full opportunity for any painstaking, intelligent young man to obtain a good practical acquaintance with the tea and grocery trades ... the place is not suitable for the indolent and wayward.' The advert was placed in Aris's *Birmingham Gazette* of 1 March 1824 by John Cadbury to announce his intention to set up shop. The architect's drawing shows a section of Bull Street including No. 93 originally published in *Personal Recollections of Birmingham* by E. Edwards in 1877.

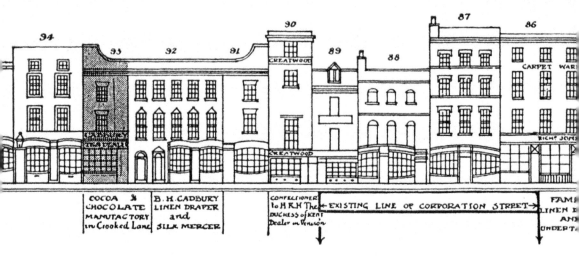

## Chocolate Assortments Arrive

The 1862 Cadbury catalogue was filled with such exotic brands as Chocolat du Mexique, Crystal Palace Chocolate, Dietetic Cocoa, Trinidad Rock Cocoa and Churchman's Cocoa. Cadbury produced Britain's first chocolate box in 1868, filled with chocolate candles and, typical of the sentimentality of the day, featuring Richard's daughter Jessica holding a kitten on the lid. Around the same time the firm produced the first Valentine's Day chocolate assortment. Their first salesman was the top-hatted and punctilious Dixon Hadaway. Travellers' samples were sampled to the trade and a pledge system was set up at the factory whereby a penny was awarded to any worker who had not succumbed to the temptation of eating the manufactured product during the week. The first page of John Cadbury's 1824 day book is shown here, and production at the Bridge Street works.

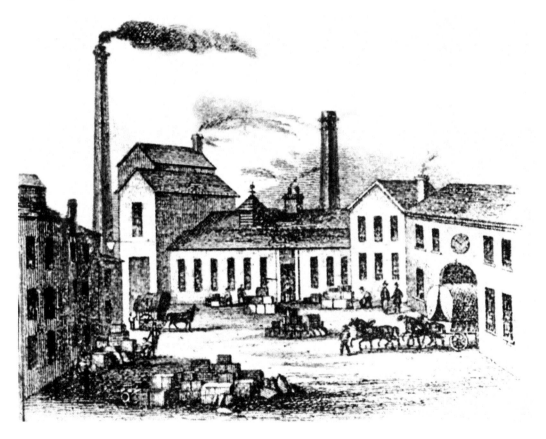

*Strictly rivate.*

## CADBURY BROS.

MANUFACTURERS OF

## COCOAS

AND

## CHOCOLATES,

BY SPECIAL APPOINTMENT TO THE QUEEN,

LONDON OFFICE, &c., 134, UPPER THAMES-ST.

### MANUFACTORY,

## BIRMINGHAM.

Paris Depot, 90, Faubourg St. Honoré.

## ALL PRICES QUOTED
### IN THIS LIST
## ARE NETT.

1st Month, 7th, 1878.

**The Vital Visit to Van Houten**
Meanwhile, back on the shop floor, things were not going well; that is, until George's 1866 visit to Coenraad van Houten to acquire one of his revolutionary presses. This visit was pivotal and eventually led the way from a company teetering on the brink of failure to the success it was soon to become. Note the prestigious address of the Paris office on this 1878 price list – French chocolate was still the most popular so the association of one's brands with things French was a shrewd marketing move. The Bull Street shop in the 1830s is shown in the other picture.

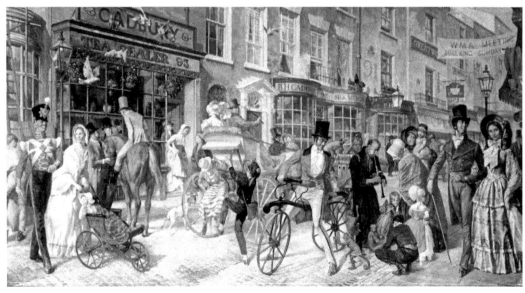

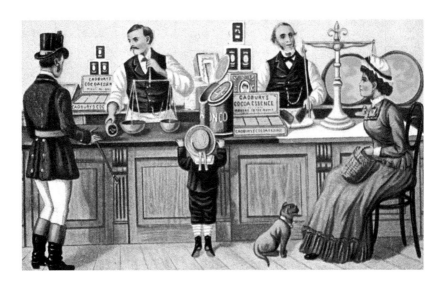

### The Influence of the *Lancet* and the *BMJ*

Eschewing any Quaker reservations about advertising, the Cadbury's set about gaining medical testimonials and establishing the health-giving credentials of their products – no doubt with an eye on manufacturers in other industries whose eye-catching posters featured glamorous women and children exuding healthiness. Both the *British Medical Journal* and the *Lancet* endorsed Cocoa Essence when launched in late 1866, the former calling it 'one of the most nutritious, digestible and restorative drinks'. The *Grocer* chimed in, emphasising the absence of adulteration. The advertising campaign devised to maximise these endorsements asserted the cocoa to be 'Absolutely Pure, Therefore Best. No Chemicals Used'. The poster above shows how middle class the clientele still was in the 1870s at this grocer's; the other picture shows the Cadbury & Fry cocoa works in the Gold Coast – the result of an agreement between the two companies whereby Cadbury would buy on behalf of both – later extended to include Rowntree.

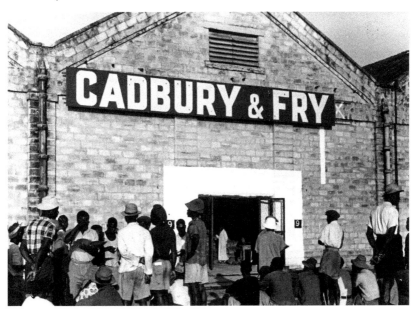

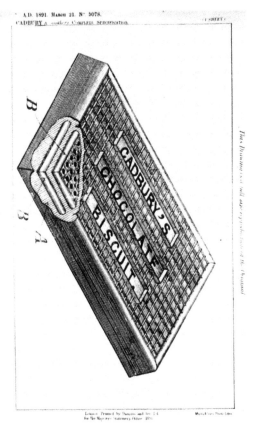

## 'The Most Exquisite Chocolate Ever to Come Under Our Notice'

The early 1870s saw the launch of the plush, decidedly un-Quakerly French-influenced Fancy Box, complete with silk lining and mirror. *Chemist & Druggist* called it 'Divine. The most exquisite chocolate ever to come under our notice'. Easter eggs arrived in 1875 and Cadbury Fingers in 1897. The illustration on the left shows the 1891 drawing for Cadbury's chocolate biscuit as presented to the Patent Office: 'very palatable and will serve as a very nourishing and tempting article of diet for travellers, invalids and others'. The other picture is from a presentation card extolling the purity of Cadbury's cocoa with testimonials from the *Analyst*, the *Medical Annual* (no potash in Cadbury's cocoa!), and *Health* which asserts that is possesses 'valuable flesh forming qualities'.

An early advertisement for Cadbury's Cocoa, one of the products of the famous Bournville works which was transported by the Midland Railway (Cadbury Ltd)

## The Kinchelman Era

The renowned French chocolatier Frederic Kinchelman was hired, bringing with him his recipes and production techniques for Nougat-Dragées, Pâte Duchesse and Avelines. One of the new lines was The Model Parish Cocoa, anticipating the model village at Bournville. Another brand was Iceland Moss, containing lichen, which was believed to be highly nutritious. Taking the fight to the enemy, Cadbury opened a shop in Paris and sales offices were set up in Ireland, Canada, Chile and Australasia. Here we see early lines and labels from the 1840s to the 1870s – note the references to France and to Queen Victoria. This and the illustrations on pages 54, 55 (top) and 56 (top) were first published in *A Century of Progress 1831–1931*. Competition from Suchard below.

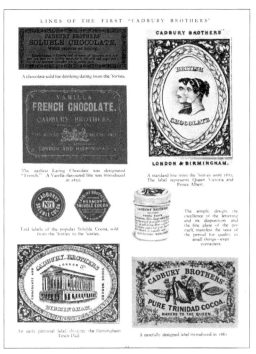

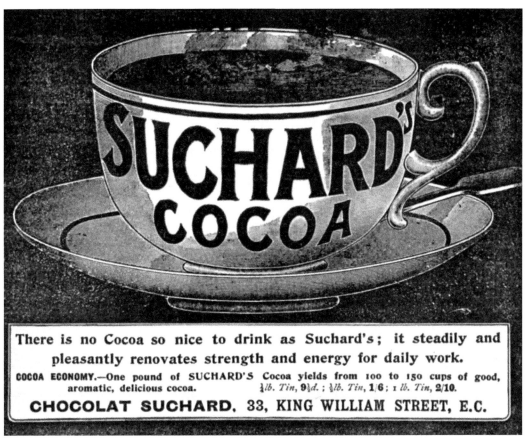

49

**CADBURY'S FLAVORED BONBONS**
MAKERS TO THE QUEEN
LONDON & BIRMINGHAM

| CINNAMON. | ALMOND. | LEMON. | SPICE. |

Bonbons of Plain Chocolate were first made in the early 'fifties, and in 1865 the "Best *Vanilla* Bonbons" appeared. In 1866 a novelty was introduced in the form of "Flavoured Bonbons" in the four flavours shown on the accompanying box label. They were a popular line for very many years.

A "Chocolate du Mexique," which was for both eating and drinking, was introduced in 1864. It was succeeded by the popular "Mexican" chocolate in 1870, which was sold later bearing labels of three different colours. "Mexican Chocolate" for its distinctive flavour and "fracture" still finds staunch support among connoisseurs.

**CADBURY'S Sixpenny Cake CHOCOLATE,** Makers To The Queen.

CADBURY'S CHOCOLATE

The "Croquette," a small, round cake of chocolate, was introduced in 1871, and was followed in 1872 by the "Dragee," a small oval-shaped chocolate "drop."

Both were presented in attractive little boxes of various shapes, of which these two are early types.

A box label of the once famous "Six-penny" Chocolate, of which thousands of tons were sold, in ½d. and 1d. sticks.

"Travellers" Chocolate in the form of long wafer sticks was for long years a favourite after its introduction in the late 'sixties. It was sold by the stick and also in small boxes. Many a Darby and Joan to-day will recall the popular 6d. box which a gallant lover was wont to present to his lass.

CADBURYS' TRAVELLERS CHOCOLATE

AND SOME NINETEENTH CENTURY SUCCESSORS

23

## Bridge Street Chocolate

Chocolates from the Bridge Street days. The four exotic-flavoured bonbons first appeared in 1866. Mexican Chocolate was launched in 1870; the croquette (middle right) came in 1871 and was a small round cake of chocolate followed the next year by the French Dragée – an oval chocolate drop. Travellers Chocolate came in long wafer sticks sold singly or in boxes. Fine Crown was another standard line quality drinking chocolate manufactured up to 1870. *Century of Progress* gives us the story of George Sara, the Plymouth representative who, in the Great Blizzard of 1891, found himself on a train that became snowbound. He gallantly handed out his Easter samples to hungry and cold passengers and, helped by the crew and their boiler, served hot chocolate down the length of the train.

FINE
CROWN.
MADE BY
J. CADBURY,
BIRMINGHAM.

'Plain Chocolate Sold in Drab Paper'
Brands from the 1860s – the *pièce de résistance* was the many fruit-flavoured Chocolat des Delices launched in 1863. Fierce competition came from the French (Chocolat Menier, for example), the Dutch (van Houten) and Swiss (Suchard, Cailler, Kohler, Tobler and Nestlé) manufacturers, as well as from Rowntree's, Fry's and companies like Taylor's in Spitalfields, manufacturers of more than fifty brands of cocoa and mustard. Also, Dunn & Hewett of Pentonville who sold chocolate sticks and patent Lentilised Chocolate (made from lentils, tapioca, sago or dried peas) and the disarmingly descriptive 'Plain Chocolate Sold in Drab Paper'.

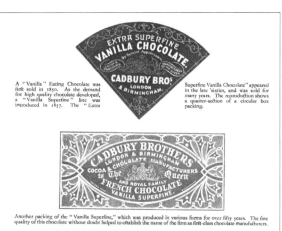

A "Vanilla" Eating Chocolate was first sold in 1850. As the demand for high quality chocolate developed, a "Vanilla Superfine" line was introduced in 1857. The "Extra Superfine Vanilla Chocolate" appeared in the late 'sixties, and was sold for many years. The reproduction shows a quarter-section of a circular box packing.

Another packing of the "Vanilla Superfine," which was produced in various forms for over fifty years. The fine quality of this chocolate without doubt helped to establish the name of the firm as first-class chocolate manufacturers.

This line, the feature of which was the fruit-flavoured creme it contained (orange, lemon, almond, raspberry, etc.), was introduced in 1866, following a former "Delices" of 1863. It was prominent among the early "Best Assorted Fancy Goods," which were the predecessors of the immense range of fancy chocolates sold to-day.

CHOCOLATE LINES OF THE 'SIXTIES

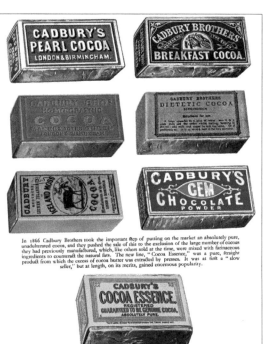

In 1866 Cadbury Brothers took the important step of putting on the market an absolutely pure, unadulterated cocoa, and they pushed the sale of this to the exclusion of the large number of cocoas they had previously manufactured, which, like others sold at the time, were mixed with farinaceous ingredients to counteract the natural fats. The new line, "Cocoa Essence," was a pure, straight product from which the excess of cocoa butter was extracted by presses. It was at first a "slow seller," but at length, on its merits, gained enormous popularity.

## Cocoa Essence

For many years cocoa was the main product; this is reflected in the wide range of advertisements and posters produced, vaunting the various qualities of Cadbury cocoa. On the left are the various cocoa powders superseded when Cocoa Essence was introduced in 1866 and a wonderfully detailed advertisement telling us everything we need to know about Cadbury's Cocoa Essence. The essence of Cocoa Essence was that it was essentially pure cocoa and did not, like the other products here, contain the farinaceous ingredients (potato starch and sago) introduced into the mix to counteract the natural fats. Cocoa Essence had its fats removed through a hydraulic press and went on to become enormously successful. Rowntree in York later had their own cocoa essences.

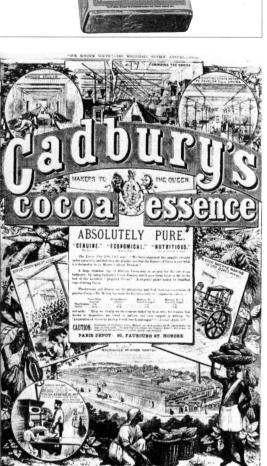

## Strength and Staying Power

These two advertisements promote the strength and stamina that Cadbury cocoa gives. Rugby players (1888) and cyclists (1887) were targeted in particular, with eight good reasons why Cadbury's cocoa is so popular. Note its head-turning powers too amongst young ladies. Richard Cadbury gives a vivid picture of the Bridge Street days in *Century of Progress*: 'On the ground floor of the factory were the store-house, the roasting ovens, the "kibling mill" and other machinery, while above was the packing room, where all was light and cheerful ... the score or more of girls ... wore a kind of industrial uniform ... everything was scrupulously clean and busy hands and bright faces made the workroom a happy place.'

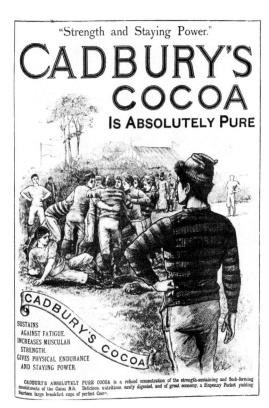

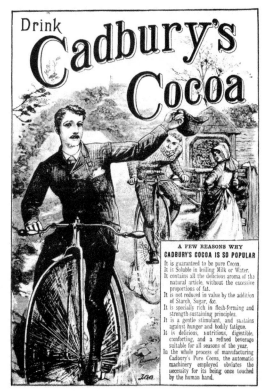

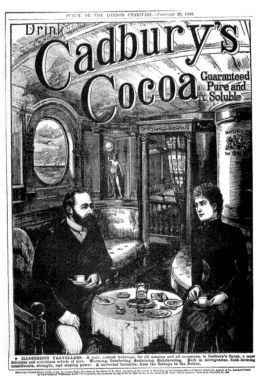

**A Brief Encounter Moment?**

The 1886 *Punch* advert is aimed at the 'illustrious traveller' and provides him and her with 'flesh-forming constituents, strength and staying power. A universal favourite, from the Cottage to the Palace'. It's good for children and infants too. Note the quotation from *The Analyst*. 'Absolutely Pure: Therefore Best' was the very successful slogan adopted to promote Cocoa Essence and convince grocers that this was the future. The addition of additives like arrowroot, potato starch, sago flour and powdered seashells, as well as iron rust or brick dust to darken the colour, was made illegal under the Food and Drugs Act 1860 and the Adulteration of Food Act of 1872. This was after a *Lancet* study in 1850 by Dr Arthur Hassall found that over half of all chocolate sampled contained brick dust.

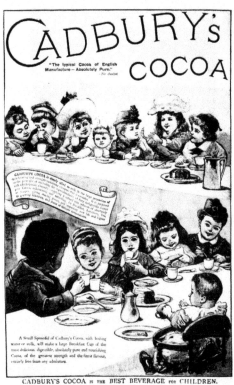

CADBURY'S COCOA is the BEST BEVERAGE for CHILDREN.

## Still the Best...

The advertisement on the left evokes the Englishness and nostalgic qualities evoked by Cadbury cocoa. The other, from the *Illustrated London News* of January 1894, has an exotic, eastern European air about it. It also mentions Dr Fridtjof Nansen's *Fram* polar expedition for which Cadbury provided 1,500 lbs of Cocoa Essence, hermetically sealed to ensure it lasted for seven years. In the event the expedition to reach the North Pole by going with the flow of the Arctic Ocean lasted from 1893 to 1896. We saw on page 17 how Fry got involved with Captain Scott; in 1910 Captain Robert Falcon Scott visited Bootham School in York to give a talk prior to the ill-fated British Antarctic Expedition's 1910 attempt at the South Pole. This was reported in Rowntree's *Cocoa Works Magazine* along with the announcement that a fund had been established to pay for a Rowntree sledge for the expedition.

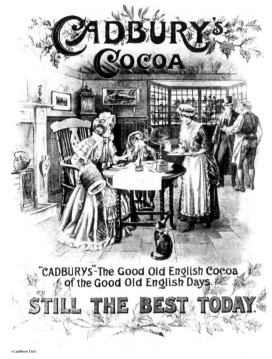

*(Cadbury Ltd)*

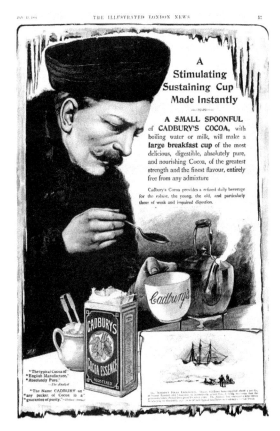

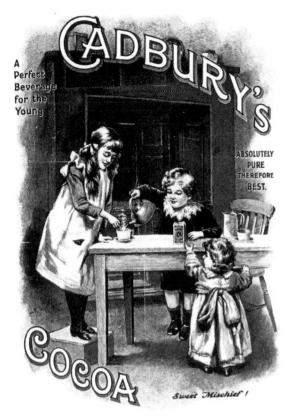

A
Perfect
Beverage
for the
Young

ABSOLUTELY
PURE
THEREFORE
BEST.

*Sweet Mischief !*

## Cocoa Lifeline

More emphases on purity and on the benefits to children. The advertisements below left show (clockwise from top right) Cadbury's with Nansen, the purity of and the possibilities of cocoa as a refreshing alternative beverage to tea amongst young and old, and the lifeline that Cadbury's cocoa offers. 'Absolutely Pure' features frequently. The association with the legal profession, to convey that cocoa drinking was the right and proper thing to do perhaps, was first shown on page 19. The lifeboat and Nansen adverts associate Cadbury cocoa very closely with the brave and the selfless.

Supplies of Cadbury's Cocoa and Chocolate, by reason of their high food value, were taken by Nansen on his first Polar Expedition.

CADBURY'S COCOA
Absolutely Pure therefore Best
NO CHEMICALS USED

Very extensively used. An advertisement which will still be remembered by most people who are over fifty.

CADBURY'S COCOA
Absolutely Pure therefore Best
NO CHEMICALS USED

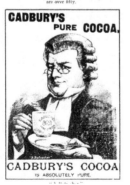

CADBURY'S PURE COCOA.

CADBURY'S COCOA
IS ABSOLUTELY PURE.

### She Was Not Amused

The Queen Victoria advertisement reinforces the associations with royalty, although Her Majesty looks far from amused ... On the chocolate front the new van Houten technology and recipes resulted in the major advance that was the chocolate bar and, in 1898, milk chocolate bars made by Daniel Peter's powdered milk technique to compete with the popular Swiss chocolate bars. Cocoa imports to the UK were increasing all the time: 1830 – 176 tons, 1880 – 4,713 tons, 1890 – 9,029 tons, 1900 – 16,888 tons. The ever-popular Richard Cadbury died unexpectedly in Jerusalem in 1899 from diphtheria. His philanthropic works included leaving his home, Moseley Hall, as a children's convalescent home, along with the building of the Bournville almshouses and the Highgate Institute for the Adult School Movement.

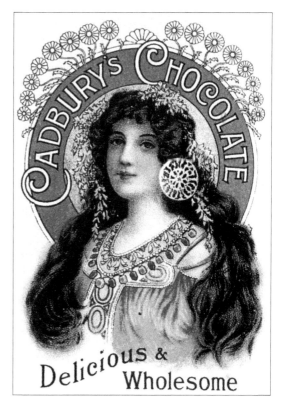

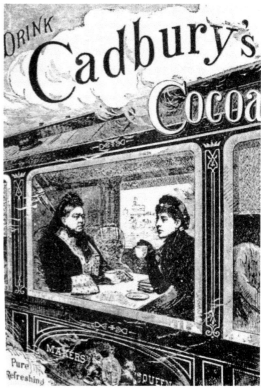

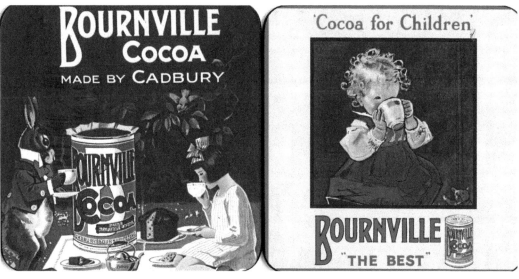

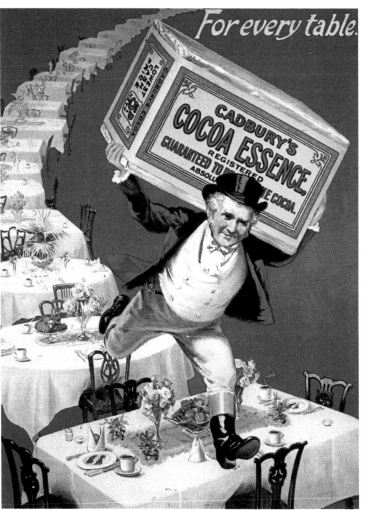

Bournville Cocoa
Bringing the
Bournville brand
to market in 1908
in the shape of
Cadbury's Bournville
dark chocolate and
Bournville Cocoa
was underscored by
a sound commercial
strategy which still
resonates today. The
brands helped to
reinforce Cadbury's
case for trademark
registration of the
Bournville name, the
application for which
was lodged in August
1909 and subsequently
granted. Bournville
Cocoa is now Fairtrade
certified. John Bull,
the quintessential
Englishman, is used
to promote Cadbury's
Cocoa Essence as the
essential English drink
in the 1905 poster.

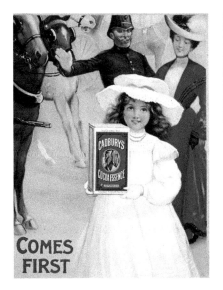
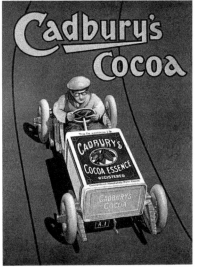

Cocoa Comes First

The importance of cocoa in everyday (middle class) life and its associations with sport, speed and adventure are evident in these two posters above. The poster below is, of course, redolent of the 1899 His Master's Voice trademark and derived from a Francis Barraud painting of Nipper the dog listening with curiosity to a phonograph cylinder. The Gramophone Company bought the copyright of the painting, changing it crucially to show one of their machines – this was used in their marketing from 1900. The Gramaphone Company became better known as His Master's Voice, opening their first HMV shop in London in 1921. Unlike Nipper, Cadbury's cat looks decidedly unimpressed by the sonic experience.

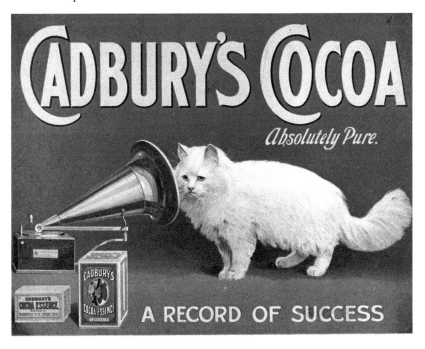

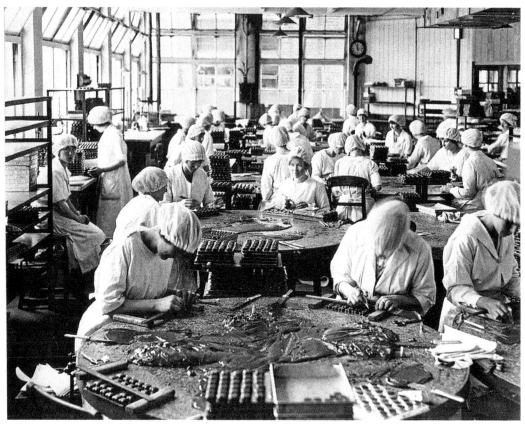

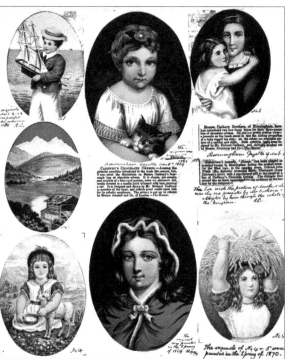

## Chocolate Assortments

Boxes of assorted chocolates, or Fancy Boxes, were an increasingly important sector of the chocolate market from the 1860s. The market was dominated by the French and it was against this competition that Cadbury launched their attack. Success depended on two crucial factors: the selection of chocolates itself with different types of fillings and, interestingly, the packaging. Richard Cadbury had the foresight to realise that the boxes themselves were crucial to the selection of the assortments by the consumer. An artist himself of no little ability, he designed a number of chocolate boxes himself with some considerable success. The pictures show a number of Richard Cadbury fancy box designs; above is a photograph of packers filling chocolate boxes at the Bournville factory.

## Chaste Yet Simple

In January 1869 the *Birmingham Gazette* reported: 'Messrs Cadbury four-ounce box of chocolate cremes is among the pictorial novelties offered to the trade. Chaste yet simple, if consists of a blue-eyed maiden some six summers old ... designed and drawn by Mr Richard Cadbury.' The 'maiden' was his daughter Jessie (see her on page 60 in the picture top middle with a number of other Richard Cadbury designs). The company had 264 assortment lines in 1897 and double that by 1904. Chocolate-covered biscuits were produced from 1889. This poster embraces all the things Cadbury strove to associate with. The image on page 60 (lower) and here (upper) were first published in *Century of Progress.*

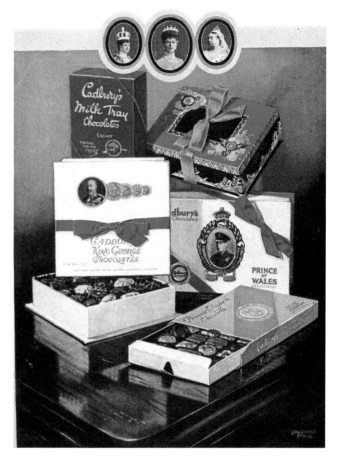

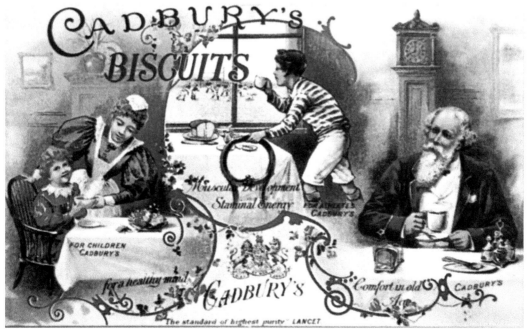

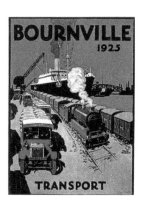

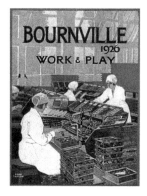

## Corporate Advertising

By the 1920s the Bournville brand was well and truly established as these attractive corporate advertisements clearly show. They depict aspects of Bournville-Cadbury's transportation activities, the idyllic work environment that was purportedly enjoyed at Bournville, their contribution to a healthy life–work balance (later adopted by Mars and the Mars Bar), their plantations in Trinidad and their association with successful business. Some 1931 facts about Bournville recorded in *A Century of Progress*: number of male employees – 3,633; female employees – 3,694; length of work streets – 2¼ miles; length of railways – 5 miles; coal consumption per annum – 30,000 tons; number of lights – 9,000; 590 telephones; 240 electric clocks; 50 lifts; 40 million cocoa tins used per annum; 30,000 gallons of milk per day, half a ton of fresh butter and 80 gallons of fresh cream. One week's production of chocolate boxes would stack up to a pile 13¾ miles high.

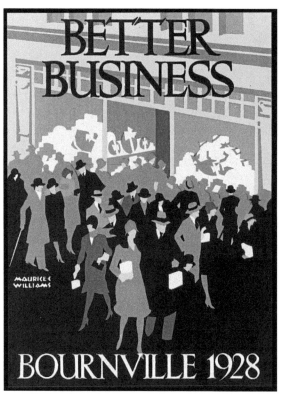

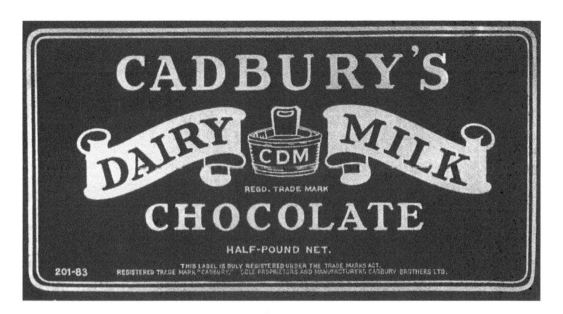

## Dairy Milk – 'a Much Daintier Name'

In 1905 the milk chocolate recipe was changed to incorporate fresh milk and the hugely successful Cadbury's Dairy Milk was born. Originally it was branded Highland Milk and then Dairy Maid but this was changed at the last minute when a representative reported that the daughter of a Plymouth customer asserted that Dairy Milk was a 'much daintier name.' Dairy Milk contained more milk than any other chocolate bar on the market: later earning the slogan 'a glass and a half of fresh milk' and by 1913 was the top-selling brand. The colour advert shows, above, early CDM packaging and, below, the range of related products available today.

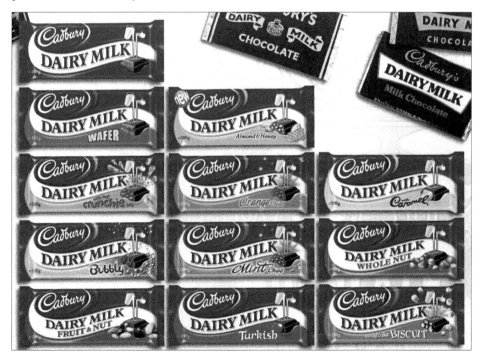

**You can't take a dairy cow motoring**

**but . . .**
**you can take the glass-and-a-half**
**of milk in a ½ lb block of**
**Cadbury's milk chocolate**

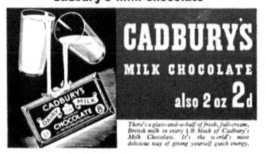

**CADBURY'S**
MILK CHOCOLATE
also 2 oz **2**d

*There's a glass-and-a-half of fresh, full-cream, British milk in every ½ lb block of Cadbury's Milk Chocolate. It's the world's most delicious way of giving yourself quick energy.*

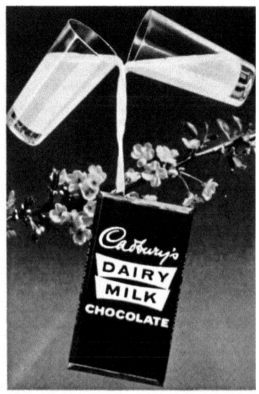

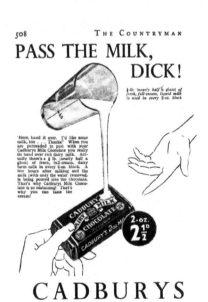

**PASS THE MILK,**
     **DICK!**

½-lb. (nearly half a glass) of fresh, full-cream, liquid milk is used in every 2-oz. block

'Here, hand it over. I'd like some milk, too . . . Thanks!' When you are persuaded to part with your Cadbury's Milk Chocolate you really do hand over rich dairy milk. Actually there's a ½ lb. (nearly half a glass) of fresh, full-cream, dairy farm milk in every 2-oz. block. A few hours after milking and the milk (with only the water removed) is being poured into the chocolate. That's why Cadbury's Milk Chocolate is so sustaining. That's why you can taste the cream!

**CADBURYS**
2-OZ. BLOCKS

**Cadbury Becomes the UK's Biggest Chocolate Maker**

CDM helped Cadbury to overtake Fry as the biggest UK manufacturer in 1910 with sales of £1,670,221 compared with Fry's £1,642,715 and Rowntree's £1,200,598. In 1928 Cadbury launched the celebrated 'Glass and a half of full cream milk in every half pound' slogan, using it initially only in advertising. In 1953 the design was first used on CDM wrappers. The intimate association with full cream milk and milk chocolate as a food can be traced in these adverts – on the left and on the right from a 1933 issue of the *Countryman*. Who was Dick?

## Chocolat Menier – The Writing's on the Wall

These interesting posters exemplify the intense competition raging in the chocolate bar market in the 1930s. Menier had been founded in Noisiel in 1825 as a pharmaceutical company with chocolate powder manufactured as a sweet coating for bitter pills. By the 1850s chocolate was taking over with chocolate bar production estimated at 4,000 tons; with a factory in London they were one of the world's biggest chocolate companies, having a substantial turnover in the UK. Production was 125,000 tons in the 1880s with 2,000 employees. In 1874 the Meniers built a model village for their workers along similar lines to Bournville and Rowentree's New Earswick. The poster here is one of the iconic 1893 Menier graffiti designs by Firmin Bouisset – unashamedly copied here by Cadbury in the 1930s. Menier's hexagonal *chocolat kiosques* with peaked roofs became the standard design for newspaper kiosks. Menier was bought by Rowntree Mackintosh in 1971.

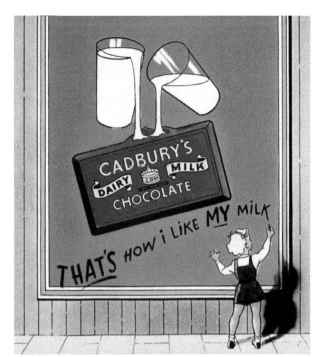

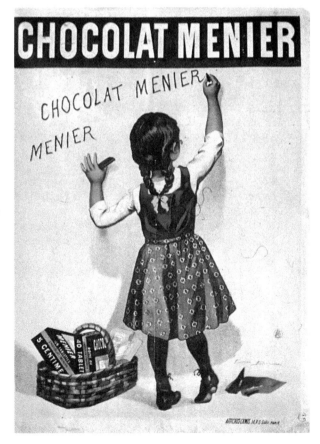

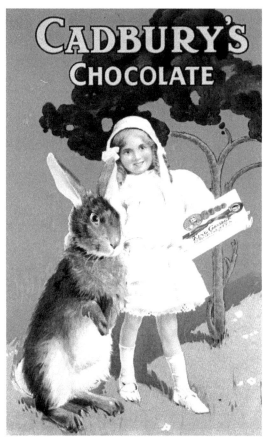

The Number 1 Chocolate Brand
CDM had become the best selling
chocolate brand in the UK by 1926.
Cadbury's CDM website gives us some
fascinating facts: 'Today, CDM remains
the UK's number one chocolate brand and
is worth more than £360 million. More
than 65% of the British population will
buy CDM at least once a year. It is also ...
enjoyed by millions of people across 30
countries ... Target audience: 21–29 year
old females, but a great deal of interest
comes from the 45 years + consumer as
well ... 500 million bars are made each
year, in the UK. Enough of Cadbury
Dairy Milk is sold every year to cover
every Premiership and Nationwide league
pitch – five times over. The amount of
milk used in a year's production of CDM
chocolate would fill 14.4 Olympic-size
swimming pools'. One pound of Cadbury
milk chocolate comprises ¾ lb of chocolate
and two pounds of liquid milk or, a glass
and a half of full cream milk. The generic
chocolate adverts show Easter eggs with
the popular Elsie and Bunny from 1912,
and the appeal to romantic couples and
cyclists, or romantic cyclists.

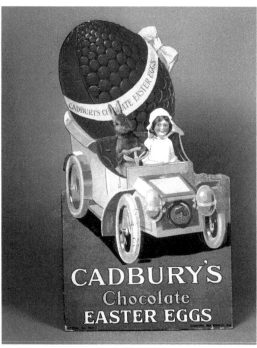

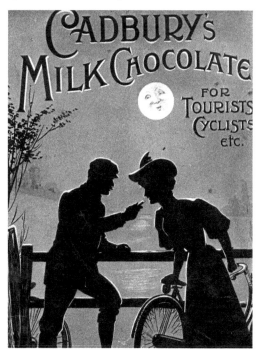

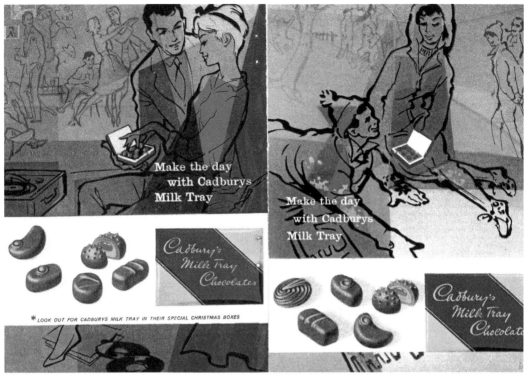

Make the day
with Cadburys
Milk Tray

*LOOK OUT FOR CADBURYS MILK TRAY IN THEIR SPECIAL CHRISTMAS BOXES*

Make the day
with Cadburys
Milk Tray

## Milk Tray and Flake

Milk Tray (the 'box for the pocket') was launched in 1915 – originally presented in open boxes on wooden trays – followed by Flake, made unusually from folds of milk chocolate, in 1920: 'the crumbliest, flakiest milk chocolate in the world'. Milk Tray packaging has barely changed in the last ninety-five years and still sells over eight million boxes annually. These distinctive adverts appeared in *Reader's Digest* magazine in 1959 to lend a cosmopolitan air to the product.

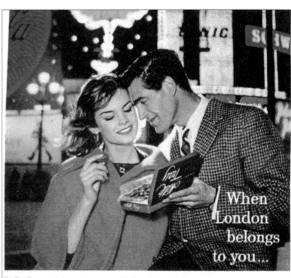

When
London
belongs
to you...

## Make the day with Cadburys Milk Tray

Make the day with a box of the most popular chocolates in the world - Cadburys Milk Tray. As well as your old favourites there are now three entirely new ones - Lime Cordial, Cokernut Ice and Hazelnut in Caramel. They're fabulous. Buy some in the smart re-styled box today.

½ lb **1'7**  ¼ lb **3'-**  1 lb **5'9**

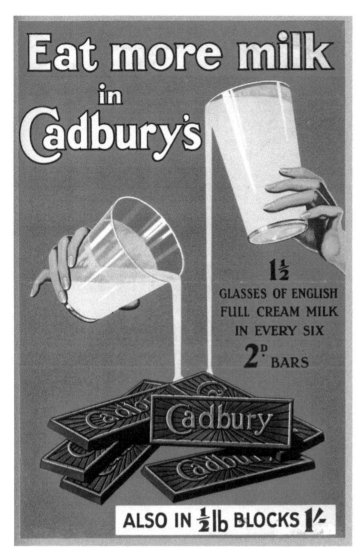

**Purple Packaging**
The famous purple packaging first wrapped Dairy Milk in 1920; the idea being to reflect the noble associations the colour has with Roman senatorial classes and emperors. The familiar Cadbury signature was first signed in 1921. The relative production costs of a bar of CDM between 1938 and 1962 are shown in the right hand illustration; pre-purple livery advert on the left.

The cost of a bar of chocolate

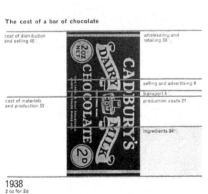

**1938**
2 oz for 2d

Ingredients account for 34 per cent of the retail price of a bar of chocolate in 1938.

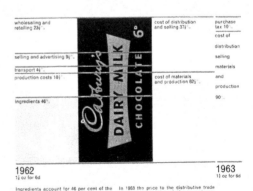

**1962**
1½ oz for 6d

**1963**
1½ oz for 6d

Ingredients account for 46 per cent of the retail price in 1962—before the imposition of purchase tax. This reflects the great increase in the price of raw materials, particularly of cocoa, but this was partially offset by improved manufacturing efficiency and lower distributors' margins.

In 1963 the price to the distributive trade included an addition of 15 per cent purchase tax, levied on the manufacturer's price. This represented 10 per cent of the price to the public.

## 66,000 Eggs Per Hour

Creme Eggs arrived in 1923. Today 66,000 eggs are 'laid' each production hour. Crunchie and Fruit & Nut were launched in 1929, and Crunchies were produced at the rate of five miles per hour at the Somerdale factory. Whole Nut hit the market in 1933. Roses Selection came in 1938 with its distinctive 'Dorothy Bag' carton; annual production today exceeds 13,000 tonnes. Label design development is clearly demonstrated in the right-hand picture. Regal connections and association with the brave and famous (in this case, Grace Darling shown during her heroic 1838 rescue off North Sunderland) are shown in the generic chocolate adverts.

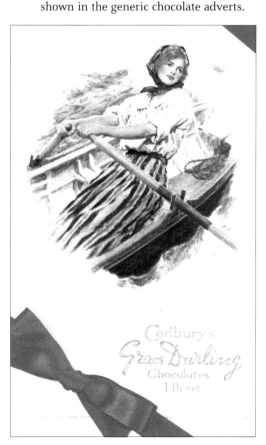

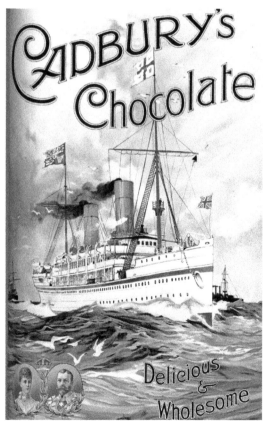

Showing the food value of
Milk Chocolate.

Heralding the now famous
" Sandwich Block."

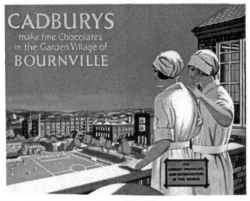

### The Factory in a Garden

In 1928, the then Minister of Health, Neville Chamberlain, inadvertently boosted Cadbury's marketing strategy when he urged the country to 'eat more milk – it is a perfect food'. This chimed perfectly with one of Cadbury's main slogans and Cadbury 'milked' it in advertisements proclaiming 'Minister of Health says "Eat More Milk"' with the famous glass and a half. Another famous slogan was their 'Factory in a Garden' shown here in the lower poster.

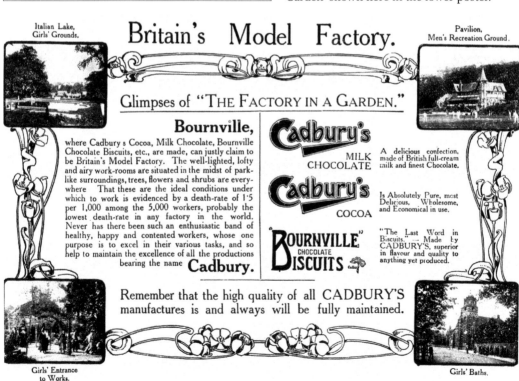

# Britain's Model Factory.

Italian Lake,
Girls' Grounds.

Pavilion,
Men's Recreation Ground.

## Glimpses of "THE FACTORY IN A GARDEN."

### Bournville,

where Cadbury s Cocoa, Milk Chocolate, Bournville Chocolate Biscuits, etc., are made, can justly claim to be Britain's Model Factory. The well-lighted, lofty and airy work-rooms are situated in the midst of park-like surroundings, trees, flowers and shrubs are everywhere. That these are the ideal conditions under which to work is evidenced by a death-rate of 1·5 per 1,000 among the 5,000 workers, probably the lowest death-rate in any factory in the world. Never has there been such an enthusiastic band of healthy, happy and contented workers, whose one purpose is to excel in their various tasks, and so help to maintain the excellence of all the productions bearing the name **Cadbury.**

**Cadbury's**
MILK
CHOCOLATE

A delicious confection, made of British full-cream milk and finest Chocolate.

**Cadbury's**
COCOA

Is Absolutely Pure, most Delicious, Wholesome, and Economical in use.

"**Bournville**"
CHOCOLATE
**Biscuits**

"The Last Word in Biscuits." — Made by CADBURY'S, superior in flavour and quality to anything yet produced.

Remember that the high quality of all CADBURY'S manufactures is and always will be fully maintained.

Girls' Entrance
to Works.

Girls' Baths.

# BOURNEVILLE

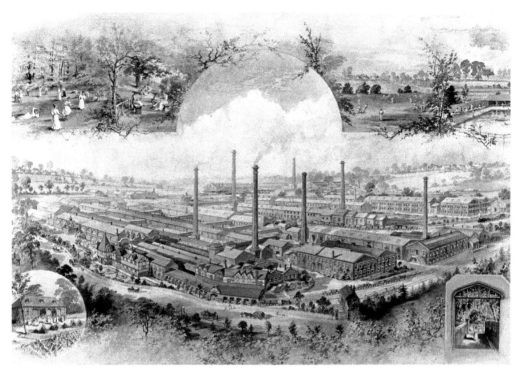

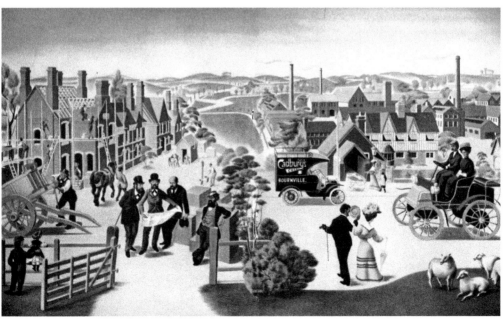

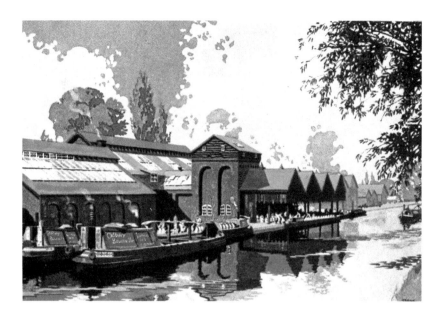

Trains and Boats...

By 1878 it had become imperative to find a site which facilitated the import of cocoa and milk and the export of finished goods. The 14½-acre Georgian Bournbrook Hall and Estate five miles south of Birmingham city centre was ideal, with access to the Birmingham West Suburban Railway and the Worcester & Birmingham Canal. It was renamed Bournville, with its French (and therefore fashionable) overtones for the opening in 1879. Cadbury were the first company to use powered canal boats with their fleet of barges in Cadbury livery. By the turn of the century sidings linked the factory with the national railway network using Cadbury rolling stock. Horse-drawn vans were the earliest mode of road transport. The image above shows the milk condensing factory at Frampton-on-Severn (built 1915) from a colour sketch by Frank Newbould.

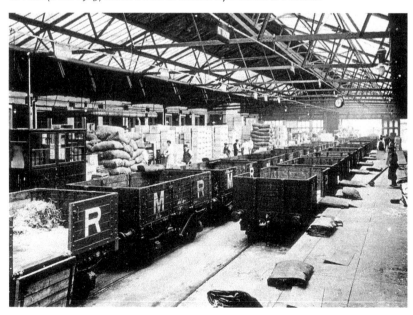

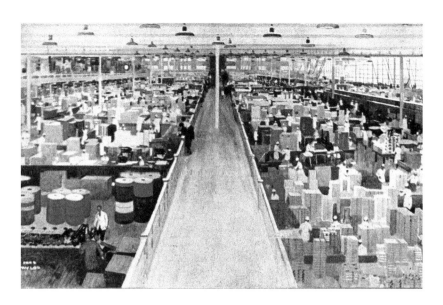

'Boxing the Chocolates'
Until the 1960s all the affiliated crafts and trades required to run a major chocolate manufacturing plant were carried out on site; these included the manufacture of boxes, cartons and tin cans, machine making, sheet metal production, printing, joinery, advertising and marketing. The colour picture shows the card box and printing department (Q Block which measured 180 x 60 metres) in full swing. The other shows 'boxing the chocolates' – in the 1950s over 900 million chocolates were packed into boxes; 450 girls made the boxes which were transported to the packing department by electric train.

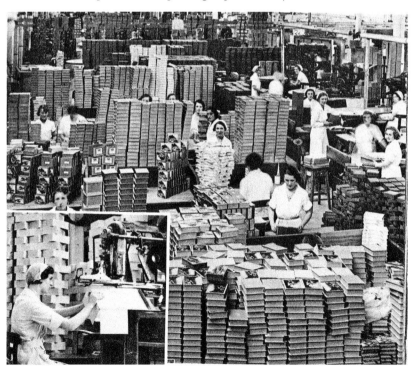

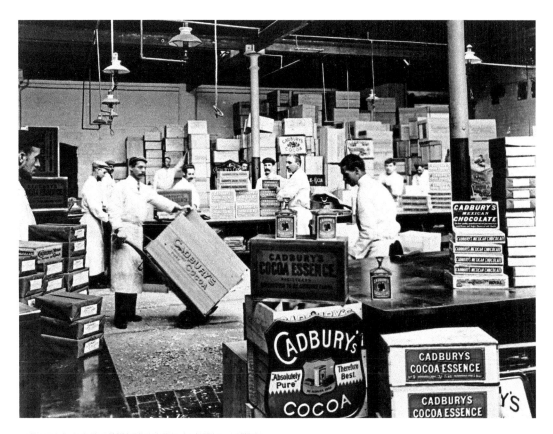

## Cadbury at War ... With the Queen

During the Boer War, Queen Victoria instructed George Cadbury to send 120,000 tins of chocolate out to the troops. At first he refused on account of his Quaker pacifist leanings. Victoria responded tartly, pointing out that this was not a request but a royal command. The issue was resolved by splitting the order with fellow Quakers Fry and Rowntree and the tins were duly despatched, unbranded to obscure their origin, with each tin containing half a block of vanilla chocolate. George Cadbury eased his conscience by producing and sending out over one million anti-war pamphlets. The importance of chocolate in military circles was highlighted by the 1905 issue of *War Office Times & Naval Review*: 'Now chocolate is ... the sweetmeat of the Services: on the march, at manoeuvres, or on any special occasion where staying power is needed.' The photograph on the right is of the 'churn tower' at the Knighton factory built in 1911 and, like Frampton, connected to Bournville by canal. Packing for export around 1900 can be seen above.

## The First World War

Fourteen years after the Boer War, confectionery tins were sent to the troops in the trenches; they contained sweets, chocolates and, in a compartment at the base of Rowntree's, a set of postcards. Initially at least the fall off in demand caused by the privations of the First World War had surprisingly little impact on sales and profits – it was amply compensated for by these government orders. Nevertheless, tariffs on cocoa and sugar increased and postal charges and general taxation had risen. The photographs on pages 75–77 are taken from *Bournville Personalities*, published during the Second World War. These two show Mary, chocolate box painter, and a lady who cracks and tests (by smell) 4,000 newly laid eggs every day. During the First World War, seventy-one Cadbury employees received awards. All jobs were kept open and 28,000 parcels of chocolate and 40,000 books were sent out. Married men were allowed 66 per cent of their previous wages and single men 33 per cent. Grants were paid to widows or the wives of disabled men.

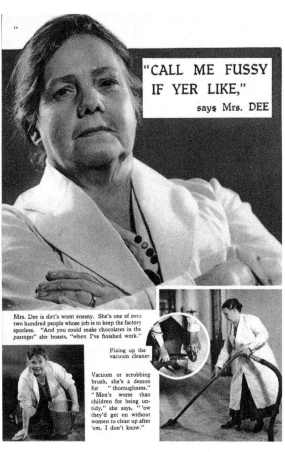

"CALL ME FUSSY IF YER LIKE," says Mrs. DEE

Mrs. Dee is dirt's worst enemy. She's one of over two hundred people whose job is to keep the factory spotless. "And you could make chocolates in the *passages*" she boasts, "when I've finished work."

Fixing up the vacuum cleaner.

Vacuum or scrubbing brush, she's a demon for "thoroughness." "Men's worse than children for being untidy," she says, "'ow they'd get on without women to clean up after 'em, I don't know."

### The German Blockade

Manpower shortages became critical as men joined up: at Cadbury alone 1,700 out of 3,000 men enlisted in the Army and Navy (218 did not return) with another 700 seconded to munitions work. German submarines blockaded the British Isles, forcing the government to ensure essential foods such as milk and cocoa were in good supply; this helped the chocolate companies. The *Personalities* are the redoubtable Mrs Dee, 'dirt's worst enemy' who boasts that 'you could make chocolates in the corridor when I've finished work ... men's worse than children for being untidy', and the chemists.

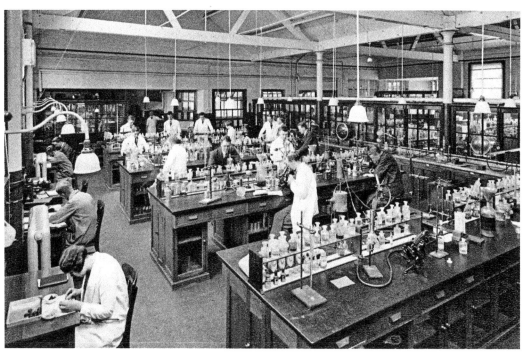

## "THE DOCTOR WILL SEE YOU NOW" says NURSE WILLIAMS

Nurse Williams and two other nurses work in Bournville's modern surgery. They can produce the health record of anyone in the factory. All new employees see the doctor before they start.

"Turn please", says Nurse Williams, and the sun-ray class moves round. Last year hundreds of regular cold-getters escaped without a sneeze. Free sun-ray is only one of four cold-prevention schemes for employees.

"Can I see the Dentist, please Nurse"? Which one? There are three dental surgeries on the factory. If you're under 18, treatment is free—and tooth-powder and brushes cost nothing if you're under 16.

### Sun-Ray Treatment

The photograph below shows a free sun ray treatment session; the Bournville doctors always followed a progressive preventative policy of keeping employees healthy rather than just treating them when they were unwell. The sun-ray sessions were an example of this and one of four cold prevention schemes in the factory. 'Health Hints' were circulated to all departments. Nurse Williams, along with two colleagues, looked after all staff (who took a medical on joining); there were three dental surgeries with free treatment for under-18s and free tooth powder and brushes for the under-16s.

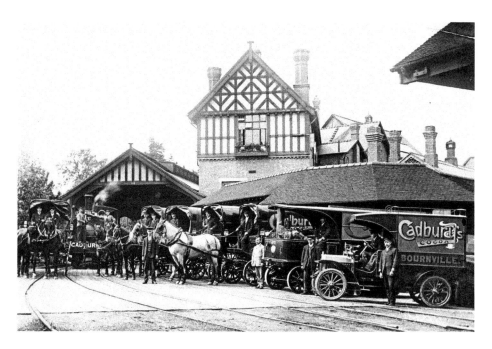

Transport

Steam- and horse-powered vehicles waiting to go at the turn of the twentieth century; the first petrol vans were introduced in 1906. Sugar shortages in the First World War caused many brands to be shelved for the duration while others were forced into adapted recipes. Cadbury's also provided books and clothing for the troops.

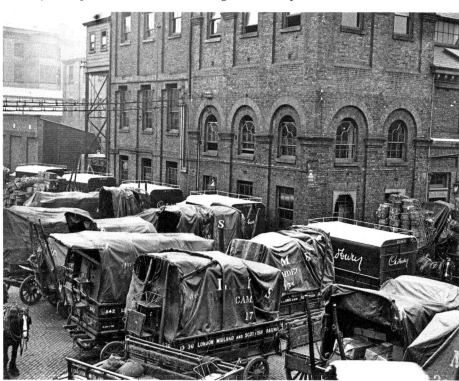

## Cocoa Beans

On arrival from the Gold Coast, the cocoa beans are cleaned by blasts of air and roasted for an hour in cylindrical, revolving ovens by gas jets; each oven holding 1,000 lbs of beans. The roasting releases the familiar aroma – and the husks – and become cocoa nibs which are then ground down. This in turn releases the cocoa butter (50 per cent of every bean) to produce a chocolate-coloured, thick creamy 'mass'. 6,000 lbs of hydraulic pressure (van Houten's press) crushes the mass to extract the cocoa butter – clear and golden and used later to make solid chocolate. Both photographs were published in *Bournville: The Factory in a Garden.*

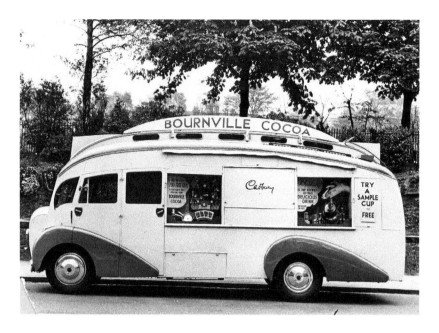

### 'Alleviating the Evils'

The pictures show two early forms of mobile advertising. The ergonomic and homely Bournville factory was, of course, only half of the Cadbury vision; Bournville village completed the equation. The deeds he handed over to the Bournville Village Trust in 1900 leave no doubt about George Cadbury's intentions and objectives: 'The Founder is desirous of alleviating the evils which arise from the insanitary and insufficient accommodation supplied to the large numbers of the working classes, and to securing to workers in the factories some of the advantages of outdoor village life, with opportunities for the natural and healthful occupation of cultivating the soil ... by the provision of improved dwellings, with gardens and open spaces to be enjoyed therewith.'

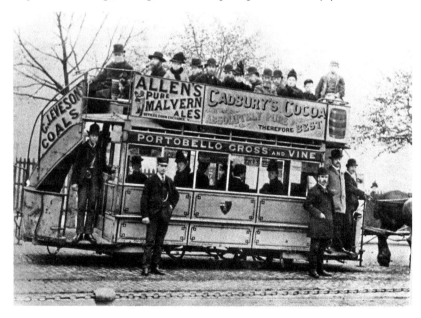

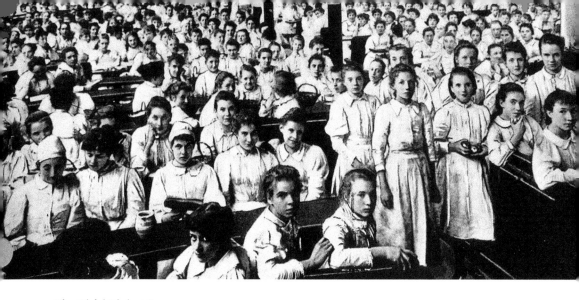

## The Girls' Dining Room

The eleven dining rooms cater for 5,000 diners every day. The dining room block built between 1918 and 1927 also houses youth club rooms and the Concert Hall seating 1,050 and, in the basement, dressing rooms for 5,000 girls. The library and doctor's and dentist's are in there too. The many clubs meet here, for example camera, chess, ambulance corps, folk dancing and 'fur and feather'. All in all 70 per cent of employees are in one club or another.

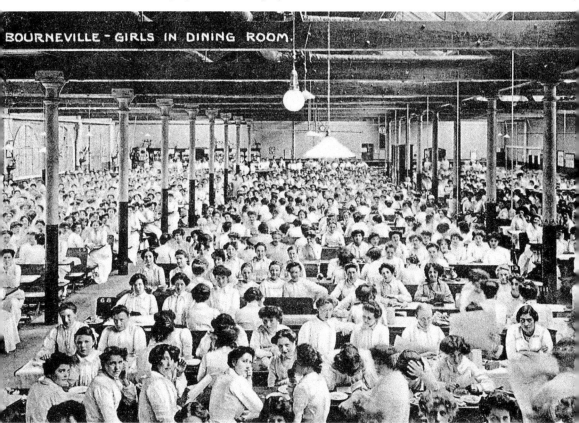

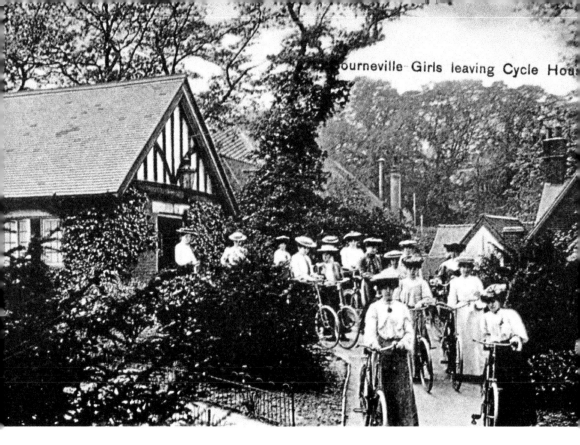

### In Front of the Girls' Cycle Shed

The girls' cycle shed around 1907 can be seen in the picture above, later the offices of the Bournville Village Trust accountants. On the right are girls going to work in the 1890s; in the middle workers arrive at Bournville station in the 1920s. In the early days women were always in the majority: apart from in 1893 numbers grew year on year and they were not outnumbered by men until 1919. Every year up to 700 women were hired, although these were offset by 100 or so girls leaving to marry – the only married women employed were part-time factory cleaners. Male and female exits and entrances were arranged so that the sexes did not come into contact with each other.

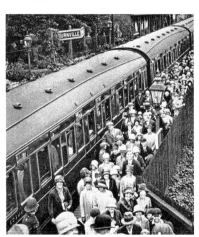

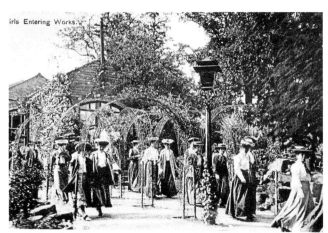

irls Entering Works.

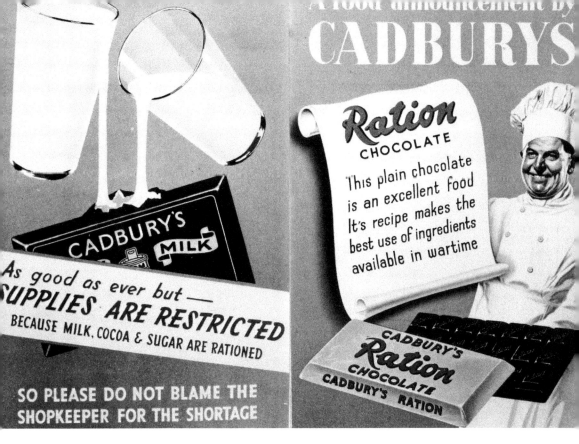

A food announcement by CADBURYS

Ration CHOCOLATE

This plain chocolate is an excellent food It's recipe makes the best use of ingredients available in wartime

CADBURY'S MILK

As good as ever but —
SUPPLIES ARE RESTRICTED
BECAUSE MILK, COCOA & SUGAR ARE RATIONED

SO PLEASE DO NOT BLAME THE
SHOPKEEPER FOR THE SHORTAGE

CADBURY'S Ration CHOCOLATE
CADBURY'S RATION

**Don't Blame the Shopkeeper**

Chocolate was rationed from 1942, with three ounces allowed per person per week – half the average pre-war consumption – and supply shared between no fewer than 181 firms. Chocolate companies, or parts of them, were either transformed completely to help the war effort or else hosted other war manufacturers. Acres of camouflage made from dyed hessian covered the factory buildings to conceal them from German aerial intelligence.

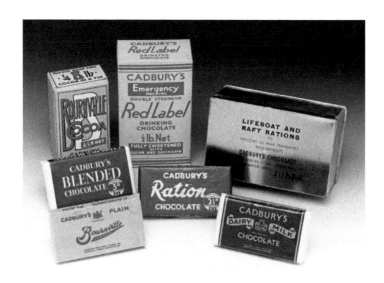

## Ration Chocolate

Imports of raw materials were seriously compromised; the shortages which developed as a result, and the diversion of the domestic supply of milk, affected the quality of major brands. Dairy Milk disappeared from the shops when milk was reserved for priority manufacturing use in 1941; Ration Chocolate replaced it, made from skimmed milk powder. The only significant damage wreaked on Bournville was on 3 December 1940 when a bomb hit and breached the aqueduct carrying the canal over Bournville Lane, causing flooding to parts of the factory and some streets. The photograph above shows gas respirator manufacture at Birmingham Utilities by 600 workers – the opening order for 5,117,039 Service Respirators and 6,335,454 canisters were completed but never used as gas warfare never materialised.

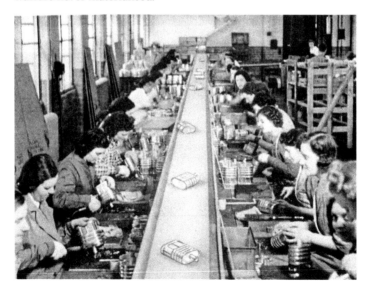

## Bournville Utilities Ltd

In 1940, Bournville Utilities Ltd was set up and 2,000 employees were transferred to the new company to help the war effort: the Moulding Department produced gun doors for Spitfires, air-intake and super-charger controls for Stirlings and flare cases for other aeroplanes. Packing made the gas masks while Metals turned out pilots' seats for Defiants, junction boxes for Wellingtons and upper-mid gun turrets for Stirlings. Other departments churned out jerry cans, fuel tanks (pictured here) for Spitfires, Beaufighters and Lancasters, and for Vosper motor torpedo boats.

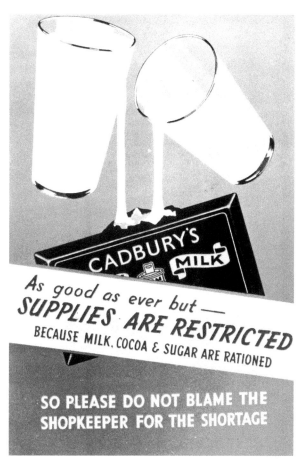

As good as ever but —
SUPPLIES ARE RESTRICTED
BECAUSE MILK, COCOA & SUGAR ARE RATIONED

SO PLEASE DO NOT BLAME THE SHOPKEEPER FOR THE SHORTAGE

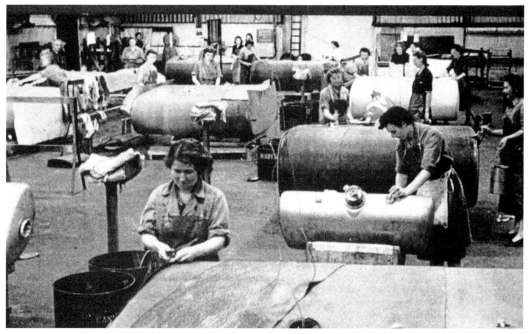

## THE CHANGING PATTERN OF SALES

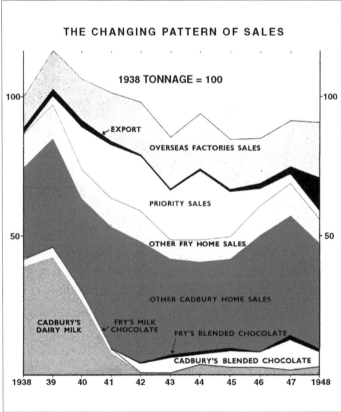

1938 TONNAGE = 100

EXPORT

OVERSEAS FACTORIES SALES

PRIORITY SALES

OTHER FRY HOME SALES

OTHER CADBURY HOME SALES

CADBURY'S DAIRY MILK

FRY'S MILK CHOCOLATE

FRY'S BLENDED CHOCOLATE

CADBURY'S BLENDED CHOCOLATE

1938 39 40 41 42 43 44 45 46 47 1948

**Nimble-Fingered Women**
Parts of the Bournville factory were also let to Austin for the production of aircraft gun magazines and helmets, and to Lucas to make rotating gun turrets and Sten gun magazines. Cadbury filled anti-aircraft rockets with explosives, pictured here. Of the 600 gas mask and cylinder workers, a mere fifteen were men as the work required the 'nimble fingers' of women. Sheep grazed on the green while 'mercy vans' with hot cocoa were sent into the Birmingham city centre during raids. The recreation fields were Dug for Victory and the Cadbury Home Guard (see page 83) was formed along with fire watchers, Fire and Ambulance Services and the ARP.

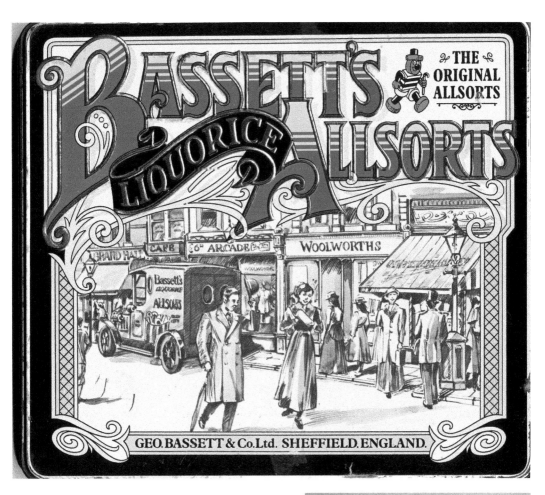

### Ssschh ... Here Comes Schweppes

In 1969 Cadbury merged with Schweppes – a firm founded in Geneva in 1783 by Jean Jacob Schweppe who had just perfected a method of carbonating water. The merger took place despite Cadbury's misgivings about Schweppes' association with alcohol (their soft drinks are used as mixers) and the impact this would have on Quaker temperance – one of the original *raison d'êtres* for championing cocoa manufacture in the previous century. Curly Wurly, Double Decker, Star Bar and Caramel were next to come off the production lines. In 1978 Chunky Dairy Milk was developed to counter Rowntree's highly successful Yorkie. In 1981 Wispa was successfully launched to compete with Aero, tactically withdrawn and then re-launched in 1983, backed by Cadbury's biggest-ever marketing campaign. In 1988 Cadbury purchased first the Lion Confectionery Company of Cleckheaton (famous for Midget Gems) and Sheffield-based Trebor Bassett.

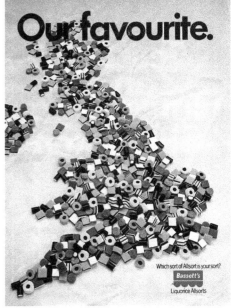

## Creme Eggs

Every year 700 million Creme Eggs are laid. The Cadbury Creme Egg web page tells us that research findings 'show that 53% of people will bite off the top, lick out the goo and then eat the chocolate and 20% of people will just bite straight through, whilst 16% of people use their finger to scoop out the creme'. The Creme Egg brand is worth £50 million per year in the UK. The illustrations are taken from *Conundrum: The Cadbury's Creme Egg Mystery* written by Don Shaw and illustrated by Nick Price. A careful reading of this 1984 book revealed the locations of the ownership certificates for twelve golden eggs that Cadbury commissioned Garrard, the Crown Jewellers, to manufacture. Each one is 22 carat gold, uniquely enamelled and containing 8 ounces of gold – value in 1984 £10,000 minimum.

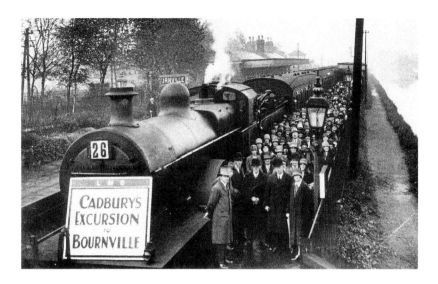

## Cadbury World

Cadbury was quick to recognise the value of good public relations. They set up a Visitors' Department as early as 1902 and were welcoming 150,000 people a day up to 1939 – many on organised bus or rail excursions. A 2-mile tour of the factory and Bournville awaited them with refreshments and a film. Only Hitler and Health & Safety stopped the flow when in 1970 regulations demanded that visitors comply with the same rigorous hygiene procedures as production line workers. But, like Hitler, Health & Safety would not get away with it. Popular demand led to the establishment of the £6 million Cadbury World in 1990 with 420,000 visitors going through the doors soon after opening. Research has shown that visitors were more likely to buy Cadbury confectionery products than any other up to twenty years following their visit. The pictures depict Bournville Station geared up for visitors in 1902 and in 2011. The picture above shows the arrival of the first ever trainload of visitors.

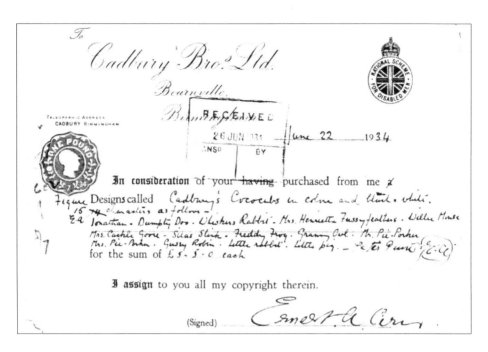

### Cadbury's Cococub Club

Cadbury's Cococub Club was a hugely successful children's club with a magazine which could claim 300,000 members at its peak and focussed on the adventures of a character named Jonathan. It grew out of an equally successful campaign in 1936 featuring a special tin of cocoa targeted at children and containing highly collectible free miniature animal characters such as Nutty Squirrel, Dan Crow and Monty Monkey. The images on the next four pages are taken from Dudley Chignall's two excellent books on the Club – *Ernest Aris: The Man Who Drew for Beatrix Potter* and *The Cadbury Cococubs*. On this page we have Dudley Chignall's original and quite unique 1934 certificate in which Aris assigned the copyright for his anthropomorphic figures over to Cadbury for £78.75. Below is the only known example of the sales pack and sample box given to Cadbury travellers: it contained a set of Cococubs, a cocoa tin, photos and advertising leaflets.

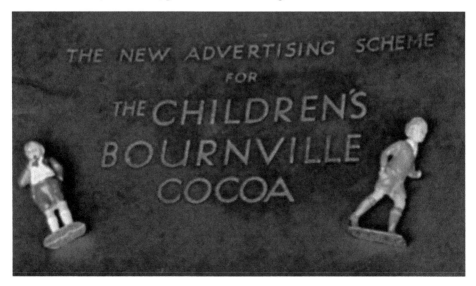

'One of the Cleverest Publicity Schemes of the Year'

So said *The Grocery and the Provision Merchant Journal* adding 'it is difficult to overestimate the sales value of such a scheme'. The campaign began surreptitiously in October 1934 with a series of feeder adverts introducing the Cococubs; the first toy advert appeared in February 1935 showing the coveted tins, pictured here. The picture below shows Aris's skill as a postcard artist. The two on the left – Bunnikin Brown (1909) and Wee Benjy Brown (1916) – are by his hand, the third is by celebrated artist Harry Rountree, posted in 1906. The bottom one shows the Cococub Race Game launched in 1935.

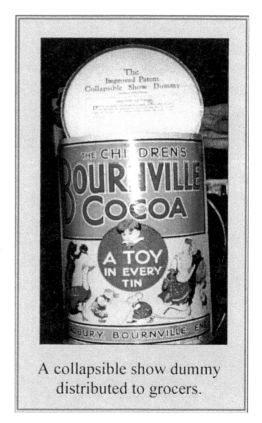

A collapsible show dummy distributed to grocers.

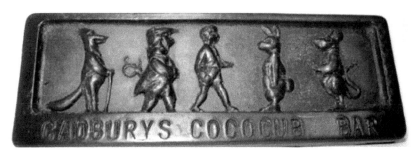

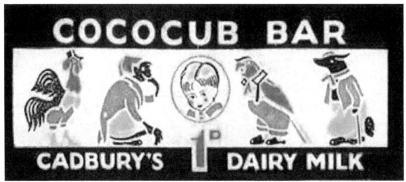

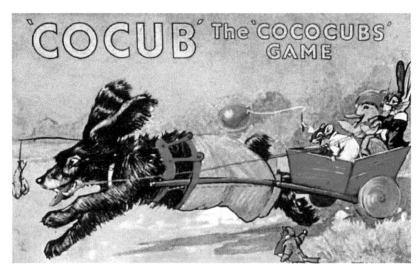

**4,500,000 Cococubs**

The top picture is a wax image of the Cococubs chocolate bar supplied by Dudley Chignall from his unique collection of Cococubs figures and ephemera – see www.cococubs.com. In the middle we have one of the three famous wrapper designs and, at the bottom, the box lid for the Cococub Game, a precursor to the Race Game pictured on page 91. It took the advent of the Second World War to bring an end to this amazing marketing success – by then over 4½ million copies of the thirty-two models had been produced for and enjoyed by the 300,000 or so members; they were made mainly by William Britain Ltd of Walthamstow. Today they are still avidly sought, coveted and collected, with a full set fetching £1,600 in 2000 at Christies.

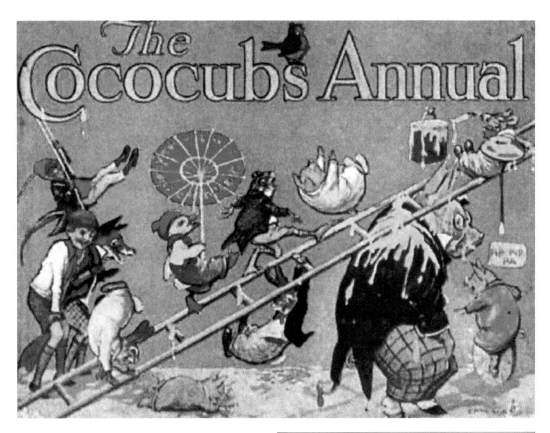

## C-Cubs

The *Annual* was published in 1936, full of cartoons following the exploits of Cococubs characters. On the right are the first fifteen Cococubs. The club was successfully re-launched in 1948 as Cadbury Cubs or C-Cubs, with Jonathan replaced by Colin, without the models. It finally closed in 1953. In his *Cadbury Cococubs* Dudley Chignall aptly describes the legacy of Aris and his Cococubs: 'Ernest had inspired Cadbury ... at a time when the United Kingdom was emerging from a depression when toys for children had only been on the shopping list of a privileged few. Between 1934 and 1937 Cadbury doubled their sales of the Children's Bournville Coco.'

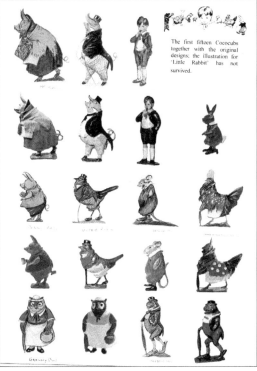

The first fifteen Cococubs together with the original designs; the illustration for 'Little Rabbit' has not survived.

## Coronation Street

Perhaps the most significant recent event was in television advertising in 1996 when Cadbury became sponsors of *Coronation Street*, Britain's longest running soap opera, now more than fifty years old. The initial annual budget was £10 million but this ensured that the Cadbury name and associated icons were on our screens at the beginning and end of each episode and at every commercial break. The purple picture displays a 'picture board' of Turkish Delight TV adverts from the 1980s.

### Voice Confectionery

More local, if somewhat specialised, competition, came from C. T. & W. Holloway – purveyors of Voice Confectionery. In 1895 Holloway somehow obtained the endorsement of the famous Spanish soprano Adelina Patti; they eponymously rebranded their lozenges Pattines, put her likeness on the tin and added the pithy Patti quotation: 'much pleased'. The Anglo-French Confectionery later pulled off a similar act of product endorsement in 1910 when Harry Lauder sent a letter praising their toffee: 'your Toffee is perfection, or as I ought to say, Your Confection is Perfection'. Competition came on a moral as well as a commercial front, as the advertisement from F. Allens shows: it depicts contrasting domestic scenes where the cocoa drinkers are paragons of temperance and prosperity while their less abstemious neighbours are immersed in intemperance and poverty. George Cadbury would surely have endorsed these sentiments.

In the Caravans of Aden
A combination of the exotic east and the modish French was provided in this enticing advertisement for M. Chabot, Parisienne confectioners. More restrained but just as fetching for all that is the Van Houten's Cocoa visiting card showing a typical Dutch scene; the verso proclaims the cocoa to be 'best and goes farthest ... easily digested and highly-nourishing ... cheap ... handy'. Early twentieth-century advertisement copy which still says everything that chocolate should be.

WHERE THE HIGH ROAD PASSES THROUGH THE VILLAGE.
Reproduced from a water-colour painting
and presented by the Manufacturers of
VAN HOUTEN'S COCOA.

P. T. O.